STEPHEN BURROWS

DANIELA MORERA, EDITOR AND ART DIRECTOR

STEPHEN B

WHEN FASHION DANCED

URROWS

Skira*Rizzoli*
NEW YORK

MUSEUM OF THE CITY OF NEW YORK

CONTENTS

Stephen Burrows in *Interview*,
September 1976

FOREWORD

SUSAN HENSHAW JONES
Ronay Menschel Director

This book and the accompanying exhibition represent the first major investigation of the work of an artist *The New York Times* called "the brightest star of American fashion." It looks at the period, spanning the 1970s, when Stephen Burrows's meteoric rise to fame made him not only the first African-American designer to gain international stature, but a celebrated fashion innovator whose work helped define the look of a generation.

It has been the Museum of the City of New York's honor to work on this project, and I want to recognize the many people who have made everything possible. The Museum's Curator of Costumes and Textiles Phyllis Magidson and co-curator Daniela Morera, who also edited and art directed this volume, spearheaded the many aspects of this endeavor. Daniela brought a unique perspective to our look at Burrows's career; as a journalist and a member of the designer's circle in the 1970s, she helped us to understand the sense of freedom and excitement that his designs expressed. They worked under the direction of Chief Curator and Deputy Director Sarah Henry, with Senior Curatorial Associate Autumn Nyiri and Lilly Tuttle. Pure+Applied designed this book, and Cooper Joseph Studio designed the exhibition. Additionally, I thank the many lenders for their generosity with their collections.

I salute our lead funder, Target. In so many ways, Target is a visionary company, and it has been the Museum's good fortune to work with them on this project. The Coby Foundation also provided invaluable support. I wholeheartedly thank the list of sponsors presented below and call out Museum trustee Laura Lofaro Freeman, who chaired the exhibition, raised funds, and gave financial support as well. Susan Madden, our SVP of External Affairs, deserves special recognition for her role in making this project possible.

Charles Tracy made his many photographs available to us in tribute to his long-time friend Stephen Burrows. Bethann Hardison was always available for help of every kind, and we all are grateful to her. And Stephen Burrows! His memories and creative input have guided this project.

Stephen's long-term business associate and close friend, the late John Robert Miller was present when the idea for this book and exhibition was first born. We dedicate this publication to his memory.

Stephen Burrows: When Fashion Danced
Exhibition Chair: Laura Lofaro Freeman

Project Sponsors:
Target
The Coby Foundation
Tiffany & Co.
Laura Lofaro Freeman
Claire and Charles Shaeffer
Nando Peretti Foundation
Furthermore: a program of the J.M. Kaplan Fund
Jamie Drake
Eric Javits Jr.
Phyllis Kossoff
Barbara and Donald Tober Foundation

BET is the media sponsor for the exhibition.

Model Aria in jacket with fur tail epaulettes, leather pants, bright colored blouse, and hat, 1978

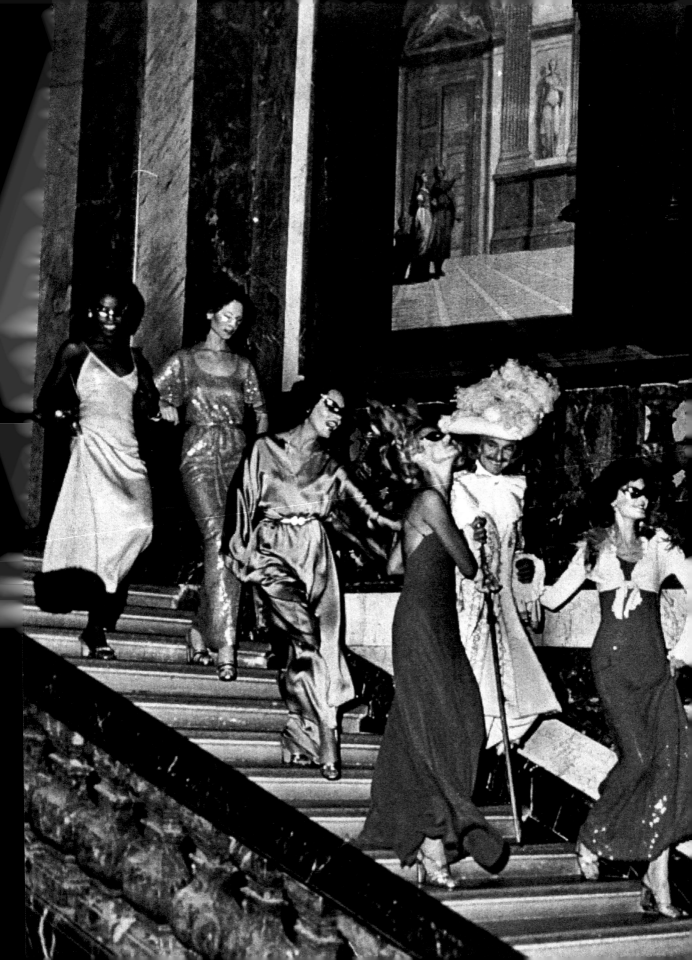

STEPHEN BURROWS: WHEN FASHION DANCED

"Something of a technician, Burrows was among the first to use seam stitching that shows—to eliminate hemlines and any stiff construction. Along with his constant investigation of new ways to cut and drape clothes, that makes him one of the more innovative designers in New York. Not just New York. Anywhere."
—Bernadine Morris, The New York Times, November 11, 1977

In 1973, Stephen Burrows created a sensation at the Palais de Versailles. In a breakthrough moment in the history of American fashion, Burrows joined Bill Blass, Halston, Anne Klein, and Oscar de la Renta at Versailles as the first American designers ever invited to show in Paris.

There, in an event staged as a fundraiser for the restoration of the palace, they faced off against five French designers chosen by the French Federation of Fashion—Marc Bohan for Christian Dior, Pierre Cardin, Hubert de Givenchy, Yves St. Laurent, and Emanuel Ungaro. At the end of the day, the upstart Americans stole the show and brought the French fashion press to their feet. Fresh, simple, and spontaneous outshone structured, sophisticated, and traditional.

Epitomizing the new mood was Burrows: with bold colors, fluid cuts, and African-American models who literally danced down the runway, his show was considered as full of life as it was full of color—and it made the French designers look staid. Columnist William Safire compared him to "the John Lindsay of eight years ago—the comer, fresh, exciting, a media favorite." That same year, Burrows won the first of what would eventually be his three American Fashion Critics' Coty Awards, becoming the first African-American recipient of that distinction. In 1977, *The New York Times* called Burrows the "brightest star of American fashion."

The fact that Burrows's models danced along the runway at Versailles was no accident; it was emblematic of a cultural moment when dance itself was taking on a new meaning in New York, Burrows's adopted hometown. During the years covered in this volume—from 1968, when Burrows opened his first boutique, to 1983, when he closed his boutique at the chic retailer Henri Bendel, which had been open for more than a decade—Burrows's work catered to and reflected New York nightlife in a state of radical transition. In the wake of the Stonewall Uprising of 1969, the John V. Lindsay administration abolished the local law that prohibited two people of the same sex dancing together, and downtown lofts became the setting for a vibrant new dance party scene. Parties characterized by continuous music, created by DJs who sought to craft a complete atmosphere through sound, generated a culture of dancing expressive of the newfound sexual liberation of the era and formulated a template for a new crop of dance clubs and for what would emerge as disco later in the 1970s.

Stephen Burrows and his clothing were close to the epicenter of this fun-seeking, hard-partying, and increasingly glamorous moment that crescendoed in the late 1970s at the legendary

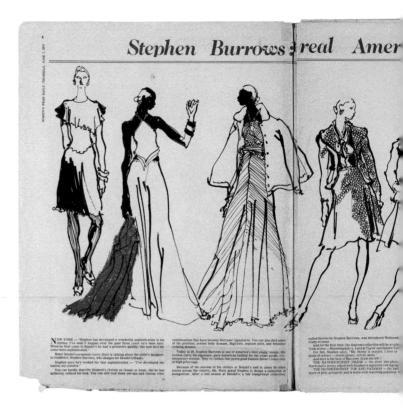

Studio 54. Burrows created a lithe, easy-moving style designed to respond to music. Along with the work of Halston and Giorgio di Sant'Angelo, his looks formed the signature style of the new Manhattan dance clubs. As a result, this seminal period of Burrows's career serves as a window into the cultural and social history of a time when New York may have struggled with crime, fiscal crisis, and physical decline, but when it simultaneously became the crucible for a new cultural spirit, driven by second-wave feminism and gay liberation. Discarding societal constraints, the city fostered a new transracial, pansexual community centered on music and dance and outfitted in exciting new fashions.

Burrows entered this world, following his upbringing in Newark, NJ and his education at the Fashion Institute of Technology (FIT), by creating pieces for his friends to wear out dancing. Marketing his creations to members of his circle and to small shops led him to work with O Boutique starting in 1968 on Park Avenue South and 19th Street—across the street from the legendary Max's Kansas City. A rock and roll venue, restaurant, and bar favored by Andy Warhol and his entourage, Max's attracted artists, rock stars,

Previous Page:
American models at Versailles, wearing (from top to bottom) Halston, Bill Blass, Oscar de la Renta, Anne Klein, Stephen Burrows, 1973

Above:
Artist Kenneth Paul Block sketched these Stephen Burrows designs for *Women's Wear Daily*'s June 7, 1973 issue. The article praised Burrows's "pure American fashion for the avant garde contemporary woman."

Following Page:
Stephen Burrows's illustration of evening wear, 1989 collection

STEPHEN BURROWS

and a range of notable luminaries from New York's creative circles of the 1960s, and Burrows quickly became the couturier for this crowd. The boutique's proximity to this hive of activity afforded Burrows's ready-to-wear line important visibility and positioned him for the most important relationship of his career: his mentorship by Geraldine Stutz, the president of Henri Bendel, the venerable upscale retailer on 57th Street that had introduced Coco Chanel to America. Burrows's friend Joel Schumacher, who worked at Bendel's and later gained fame as a filmmaker, introduced Burrows to Stutz; in his words, "It was obvious he had a fresh new voice." Stutz was on the lookout for hip new designers to inject pizzazz into uptown fashion, and in 1970 she made Stephen Burrows Bendel's designer-in-residence, providing him with his own atelier in the store. Stutz also invited Burrows to open his own in-store boutique within Bendel's, the first such enterprise for this prestigious store. Burrows's migration to 57th Street brought downtown funk to the more rarefied uptown market through the custom-designed boutique, named Stephen Burrows' World.

From the time he moved uptown to his studio at Bendel's, Burrows's work changed focus, even as he retained his vibrant aesthetic. Burrows shifted from his 1960s origins in leathers, fringes, and patchwork toward draped jersey in bold monochromatic hues, perfect for the growing dance club scene. This signature work bridged the 1960s, with its emphasis on handiwork and hippie styles, and the 1970s, and the liberation symbolized by the birth of disco and its nonchalant yet exuberant look. As the images in this volume vividly illustrate, Burrows's work in this era made an impact through blocks of brightly colored matte jersey, chiffon with "lettuce" ruffling of edges and hems, the decorative use of structured seams in contrasting thread, and red zigzag stitching. In this period Burrows also introduced the use of metallic mesh and bronze snakeskin, while continuing his affinity for leather and a bohemian look—establishing work that by 1973, in Geraldine Stutz's words, exhibited "a wonderful sophistication," in contrast to what she called the "primitive quality" of his earlier work. Designing for the fast-paced, day-to-night lifestyle of the daring 1970s woman, Burrows made his mark creating flowing garments that were showcased on the dance floor and worn by such

style icons of the era as Liza Minnelli, Diana Ross, Cicely Tyson, Farrah Fawcett, Barbra Streisand, Susan Sarandon, Cher, and Bette Midler.

The essays on the following pages explore the years in which Burrows established himself as a force in the fashion world. In her contribution, "The Salad Days of Stephen Burrows," fashion historian Laird Persson takes us into Burrows's rise to fame in the 1960s, placing him in a larger context of 20th century designers. Persson considers the major influences of Burrows's work as well as the exuberant urban cultures that received him. Museum of the City of New York curator of costumes and textiles Phyllis Magidson provides an essay entitled "Backlash to Rebirth: New York's 1960s Fashion Youth Quake," which takes the reader through the landscape of small shops and counter-cultural styles that set a new tone for fashion in New York in the 1960s. Magidson offers a tour of the neighborhood locations and stylistic innovations such as tie-dye and a rediscovery of woven and embroidered fabrics that provided a rich backdrop for the period in which Burrows cultivated his signature looks. Journalist Daniela Morera's "Ascending to Freedom," and critic Glenn O'Brien's "Stephen Burrows's World By Night" offer personal reflections on Burrows and his relationship to New York City as a center for eclectic style, artistic innovation, and decadent nightlife in the 1970s. Together, these essays paint an immersive picture of the social world that underlay the fashion industry of this period.

After the early 1980s, Burrows withdrew from the mainstream fashion world for a time, although he continued to work on made-to-order and bridal designs. He staged a major comeback in the early 2000s, reestablishing his relationship at Henri Bendel, launching a line at Target, and dressing such contemporary icons as Naomi Campbell, Naomi Watts, Oprah Winfrey, and Michelle Obama, but he never shed his relationship with the formative period of his career. A look back at that period allows a rediscovery of one of the brightest stars of a generation, whose fashions epitomized the lithe and diaphanous look of the days of disco. Through the essays, reflections, and vibrant photographs of his work, we can see the colors, places, and characters that comprised Stephen Burrows's New York and nurtured his distinctive voice as a designer.

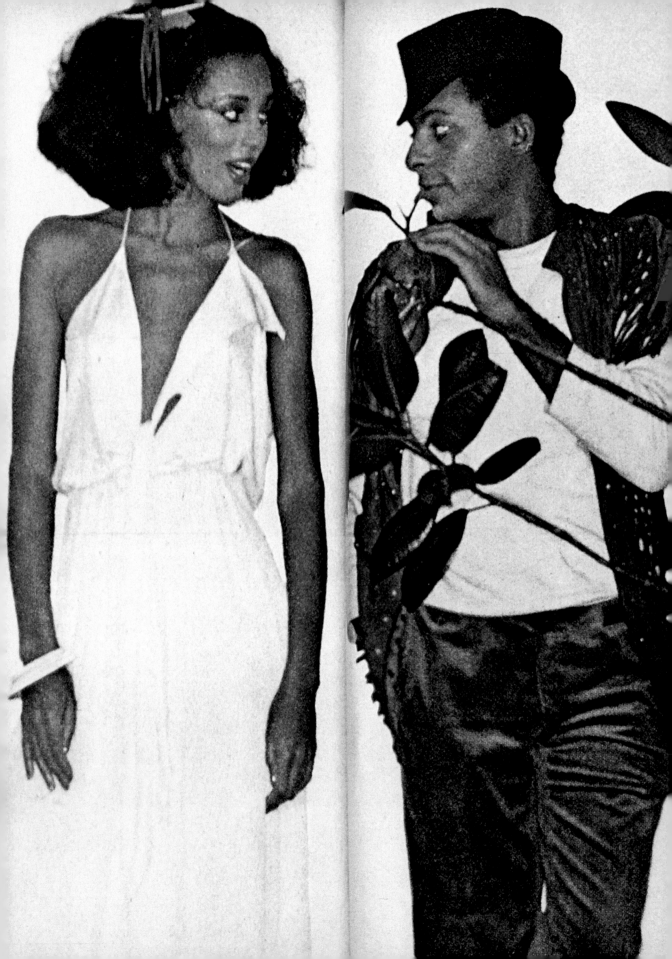

REVEL, REBEL

LAIRD PERSSON

When 1970s superstar designer Stephen Burrows was enjoying his salad days, I was a suburban baby in diapers. Studio 54 was long closed when I moved to New York decades later, and my first interaction with Burrows's colorful clothing wasn't on a dance floor, but rather on a hanger in the collection of the Museum at the Fashion Institute of Technology, where, despite the conservation-friendly low lighting, they lit up the room.

Alva Chinn and Stephen
Burrows in *Vogue*,
February 1978

Later, I came to know the designer personally and professionally, and have long been baffled by the fact that he is not better known. He deserves to be: Burrows is the rare *sui generis* designer. His work is entirely nonreferential and his technical ability extraordinary. None other than the multitalented and opinionated Karl Lagerfeld once told *Vogue* that Burrows is "the only original American designer since Claire McCardell" (who was known as "the mother of American sportswear").

Separates are certainly key to Burrows's work, but it is color of the crayon-bright variety that is his primary signature. Many of his early designs featured vivid color blocks and insets, such as those shot by Charles Tracy for *Vogue*'s trippy "Stephen Burrows is in Pepperland" story in 1970. While the designer traces the roots of his color play to his childhood, when his mother taught him to draw, others, including his muse, model Pat Cleveland, have described Burrows's color sense as "ethnic."

Color—of skin—is a subject that doesn't seem to interest Burrows much; when I asked him in a 2011 interview for *Bon* magazine if he were treated differently as a black designer, his answer was no. Yet it must be acknowledged that Burrows

is a pioneer: he is the first African-American designer to receive a Coty Award (he has nabbed three so far); the first to sign a fragrance deal; and the only designer of color to participate in the now-legendary fashion show to benefit Versailles.

What follows is the story of how a young man from New Jersey came to conquer America's fashion capital: New York, New York.

Born in 1943 in New Jersey, Burrows was raised by his mother, Octavia Pennington, and maternal grandmother, Beatrice Pennington Banks Simmons, a nurse who worked as a sample hand for upscale New York designer-retailer Hattie Carnegie, in Newark.

Fascinated by his grandmother's Zigzag sewing machine, Burrows was inspired to learn to sew, and at age eight he created his first garment, a gift for his upstairs neighbor, a lucky lass named Dolores. Years later, red zigzag-stitched hems and seams (for trimming his ruffled lettuce edges) would become one of Burrows's signature touches: he would describe them as "the blood running through my anatomical clothes." (A second-skin fit is another Burrows trademark: "I always say Stevie knows as much about the body as if he had studied premed," his mentor, Bendel's Geraldine Stutz, once said in the pages of *New York* magazine.)

It wasn't tears from glossy magazines that inspired Burrows in his youth, but music and dance. A onetime student of the Fred Astaire dancing school, the high school-age Burrows was a self-proclaimed "mambo freak," who ventured into Manhattan on Sundays to dance at the Palladium. "I began sketching dresses I wanted the girls that I met there—the partners—to wear to mambo dance," he explained in a 2011 interview. "And that was, I guess, the beginning of my falling in love with fashion, because the next thing I wanted to do was not just illustrate them, I wanted to actually see if I could make the garment that I was drawing." Little could he have imagined then that he would dress major music makers like Barbra Streisand, Cher, the Supremes, and Mick Jagger (who once flew to Bendel's for a private fitting).

While Burrows was clearly tuned in to fashion, he wasn't yet thinking of it as a career. After graduating from Newark's Arts High School, he enrolled at the Philadelphia Museum College of Art with the intention of becoming an art teacher. (His father had been skilled with a pencil.) Fate

Left:
Alva Chinn in Stephen Burrows sportswear at Versailles, 1973

Opposite (top and center):
Dress rehearsal for Stephen Burrows's show at Versailles, 1973

Opposite (below):
Burrows's show at Coty Awards, 1973

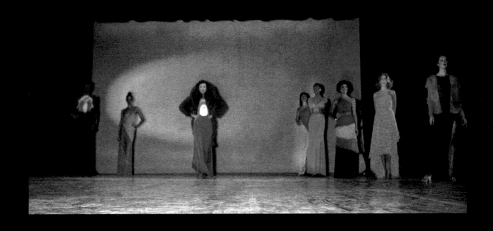

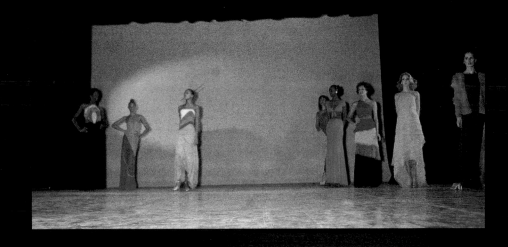

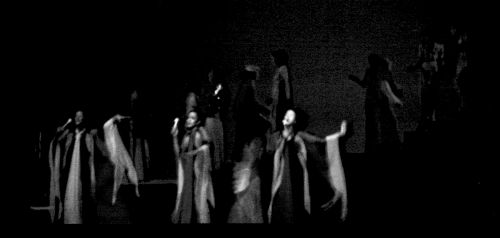

intervened during a school tour Burrows took after completing the required liberal arts courses; in the economics department—of all places—he discovered a room full of dress forms. Inanimate as they were, they brought something to life in Burrows, who decided to transfer to the Fashion Institute of Technology (FIT) and give fashion a try. He worked in display at Bamberger's department store for the spring 1964 semester, completing his studies two years later. He recalls these as happy times, during which he made lifelong friends, many of whom would be involved in his career—not to mention become dance partners. "The school was creative . . . and allowed you to be different and unique and to express yourself," recalls Burrows's friend Vy Higginsen, now a legendary producer. "We used to turn on the jukebox at lunchtime and get up and tear up the floor."

Burrows's first job out of school was with Weber Originals, a maker of missy blouses. On his own time he made going out clothes for his friends, with such success that in a year and a half he was able to quit his job. He then sold linen dresses to a shop called Outrageous in the East 20s and feather vests to Allen & Cole on East 54th Street, enmeshing himself in the city's happening boutique scene (outlined by Phyllis Magidson in her trenchant essay in this book). It was, in fact, in the column "Vogue's Own Boutique" that Burrows's work—hippie leathers and fringe—first appeared in the magazine.

Though Burrows's love affair with jersey is well documented, he works with equal adeptness with other materials, including chiffon and metal mesh, and, notably, leather. His first work with the last of these began with a cast-off from his grandmother: "She had a coat she wasn't wearing," the designer explains. "It was blue and beige leather. I cut that coat up and made me a pair of pants. I made them by hand, punching holes and lacing, and that became a big thing of mine."

While most designers work a single angle, becoming known for their mastery of bias cutting or for dressing uptown ladies, Burrows's signatures are multiple. His vision is independent of historic reference, based instead in fabric and technique. Among his "big things" is the rippled lettuce edging that adds textural interest to his jersey pieces, or the red zigzag stitching that finishes his hems and seams—and which adds more than just visual appeal, by making inner construction unnecessary.

"Burrows was among the first to use seam stitching that shows—to eliminate hemlines and any stiff construction," New York Times critic Bernadine Morris would note in 1977. "Along with his constant investigation of new ways to cut and drape clothes, this makes him one of the more inventive designers in New York. Not just New York. Anywhere." It would be a mistake, though, to think that Burrows was outside of fashion (even if he had his own "world" at Bendel's). In Paris, designers Sonia Rykiel and Karl Lagerfeld at Chloe were also deconstructing clothing and revealing its structure. Their work could also be said to have some of what New York magazine described as the "inside-out chicness" of Burrows's work.

"The '70s was really about a newness that was coming around into fashion with everything being thin and light and not so serious," Burrows would later explain. "I liked to take the lining out of everything." Unlined, his jerseys and leathers fit, as fashion journalist Kennedy Fraser observed, "as neatly as a coat of paint." (This made underwear an impossible proposition and inspired People magazine to dub him "Fashion King of the Sexy Cling.")

The body consciousness of Burrows's clothes, and their suitability for the revelry of the time, made them resonate with and even symbolize the louche life of the decade. Fernando Sanchez, a lingerie designer, has not only classified Burrows's clothes as "crazily inventive, with a fantastic sense of rhythm and body," but, speaking to the Spokesman Review in 1973, declared the trio of Burrows, Yves Saint Laurent, and Halston to be "a perfect expression of our time."

The 1970s, known as the "me decade" to many, was for Burrows and his friend Halston, really the we decade. Burrows (like Halston, who traveled with the leggy Halstonettes) had an entourage that turned heads wherever they went, be it on the subway or on the happening creative enclave of Fire Island. Some key members of Burrows's clique at that time included his FIT classmate and business advisor Roz Rubenstein, model Pat Cleveland, photographer Charles Tracy, leather designer Bobby Breslow, and designer-model Elsa Peretti. "It truly was like being in a Fellini film," recalls Rubenstein's husband, Randy Johnson: "[There were] just all kinds of people. Black people, gay people, straight people, Caucasian, Puerto Rican. It was absolutely delicious."

VOGUE'S OWN
BOUTIQUE
OF SUGGESTIONS, FINDS, AND OBSERVATIONS

We love this park—

It's just a bare plot that's turned into one of those Manhattan oases. . . . One rainy afternoon everybody there was wearing something designed by Stephen Burrows for the new O' Boutique. . . .

***One more dot of design*—**left, Stephen Burrows' cobra-hooded black wool jersey tunic striped with strips of shiny brown snakeskin. O' Boutique, 36 Park Avenue South. . . .

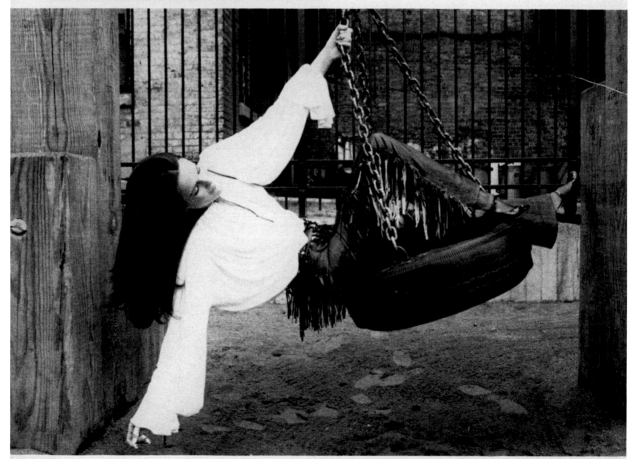

Nothing's a better swing than an old rubber tire and some chain . . . and a ravishing shirt of creamy, clingy jersey laced in at the shoulders, the wrists, with leather tapes . . . and black kid soft leather pants, fringed everywhere. . . . Pants, at O' Boutique, 36 Park Avenue South. . . .

126

VOGUE April 15, 1969

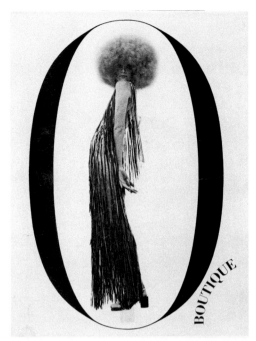

It was also as free-form as the liquid in a lava
lamp when it came to gender: "Well, it was in the
time, you know, you like who you like, and you all
like each other, girl, boy, you did it," the designer
would later reflect. This openness would inform
his garments: "Burrows," *Vogue* noted in 1969, "is
one of the first to design the any-sex, completely
modern, clothes."

These unisex clothes were sold at O Boutique,
a gallery/shop on Park Avenue South (across
from Max's Kansas City, then a favorite Warhol
hangout), which Burrows and Rubenstein opened
in 1968. Named O after the Japanese symbol of
infinity by owner and sculptor James Valkus, the
boutique was nonetheless short-lived (as none of
the parties involved had the business experience
to manage it), but O was an important launchpad
for Burrows. "People were pulling up in limousines
for these clothes," Higginsen recalls. "They came
from everywhere. This was . . . the spot, the crowd,
the group"

These innovators were soon to bring
some downtown flavor uptown. Through Joel
Schumacher, who worked at Bendel's in his
pre-Hollywood days, Burrows was introduced
to Geraldine Stutz, the store's president, who
immediately gave him a shop that she christened
Stephen Burrows' World. It was 1970 and the
twenty-six-year-old Burrows was "the brightest
star of American fashion," said *The New York*

Times, noting: "He did things with clothes that had
never been done before and he did them with style
and panache."

Burrows, whom Rubenstein once described
as "Peter Pan," imbued his fashions with youth and
vibrancy, and his success was immediate. Stephen
Burrows' World became the playground that all
the cool kids wanted to play in. "One of the things
I remember," editor Grace Mirabella would later
recall, "was that whole Bendel crowd that was . . .
wearing Stephen Burrows. I remember that was
the conversation: 'Are you going to go over and see
what he's got?'"

Burrows presented his first runway show in
his Bendel's boutique in August 1970. Kennedy
Fraser described the scene in the *New Yorker:* "The
spectators stamped their feet and stretched out
their hands to the clothes and the girls, whose
performance reduced Saint Laurent's current
games with Carmen Miranda outfits to a modest
giggle suppressed behind a lady's clean white
glove." The *New York Times* fashion critic was
less poetic, more direct, writing: "Watch out, now.
Fashions for the '70s have finally arrived in town."

For any young designer to be the talk of the
town with a Fifth Avenue business address is a
big deal, but Burrows's triumph had additional
significance; because, as Morris would note in *The
Fashion Makers* (New York: Random House, 1978),
"he was recognized as a black designer and this

helped pave the way for other blacks in the fashion field." Burrows's success at Bendel's would be one of many "firsts" he achieved in a pioneering career, one of the highlights of which was the 1973 Versailles fashion show.

Organized as a benefit to aid in the restoration of the Sun King's palace, the event was planned as a showcase for the work of five French and five American designers. It has, over time, become retold as a story of rivalry and competition. It was an important event in that it overturned the ages-old assumption that French fashion was nonpareil, and American merely mimetic. The American contingent stole the show, with spectators throwing their programs in the air after Burrows's segment featuring clothes that *Vogue* described as being "like tropical— Pop-ical—butterflies."

Despite his crowd-pleasing success at Versailles, Burrows's career would soon take on the peripatetic nature of a butterfly's trajectory. When he abruptly left Bendel's in 1973 to create his own company and take on Seventh Avenue, it seemed like the Next Big Step: he formed a partnership with Ben Shaw, who launched Halston (Halston made the introduction), and Oscar de la Renta. He signed a fragrance deal for "Stephen B.," which was promoted with Charlie-esque ads featuring the designer and the tag line: "Alive. Laughing. Dancing. Fresh. And sexy."

But the designer who once told the *Palm Beach Daily News* that "clothes should be fun and easy to move in. To me, they're like toys for adults to play with," was to discover that Seventh Avenue was all work and no play. In the end, neither the clothing nor the scent had legs. Burrows's personal, "boutique" touch didn't translate to a mass audience.

Bendel's gave the designer a second chance, and in 1977 he returned to Fifth Avenue to work with Pat Tennant, head of Bendel's design studio. His comeback was received with raves; yet times were changing. The ebullience that characterized the earlier part of the decade started to seem out of place amongst worries about recession, oil prices, and the hostage crisis. In 1982, Burrows would go his own way, intermittently returning to the fashion fray.

Like Gloria Gaynor, Burrows is a survivor. He is also, in the words of his friend Vy Higginsen, "an original piece of work"—an estimation he might agree with. Indeed, in 1980 he told *Ebony*: "My philosophy has always been to go against the rules. In school they teach you certain basics that you need to know, but when they told me at the Fashion Institute of Technology that everything had to be on the straight or seams couldn't be crooked, I just did it my way."

Unattributed quotations are drawn from interviews by John Robert Miller and by the author.

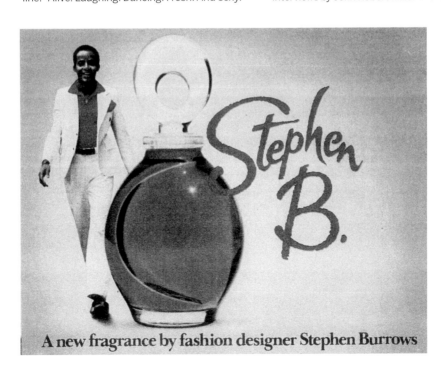

Stephen B.

A new fragrance by fashion designer Stephen Burrows

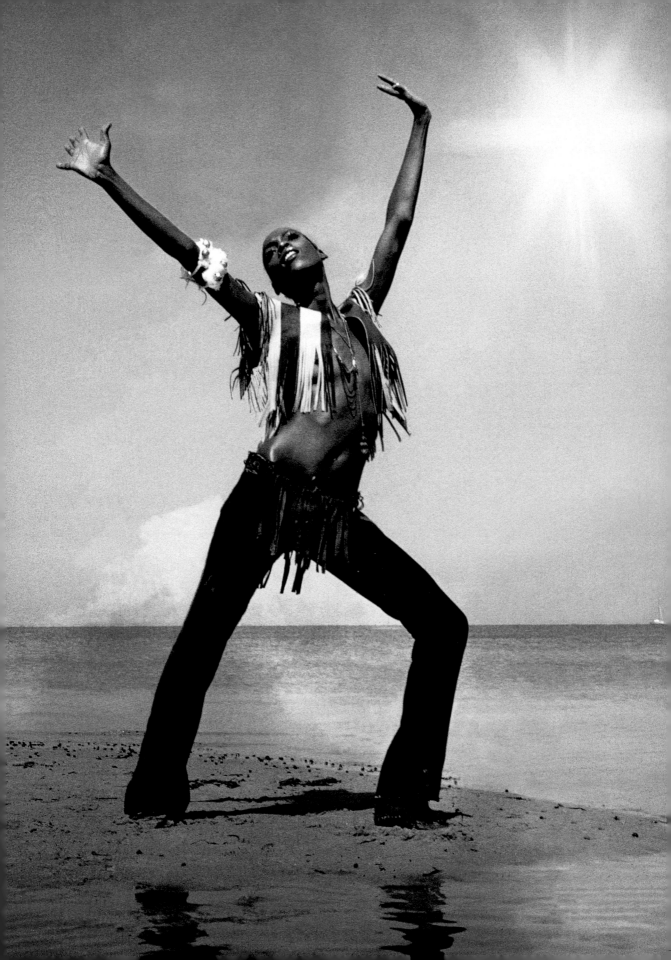

BACKLASH TO REBIRTH: NEW YORK'S 1960S FASHION YOUTH QUAKE

PHYLLIS MAGIDSON

There was a moment when getting dressed in the morning was worth getting up for—it defined your identity for the day and the way you wanted the world to perceive your persona. You were your clothing, and fashion was a celebration of life, love, and freedom. Living was dressing for the occasion and dancing down the streets of New York—this was that moment.

Naomi Sims in fringed
leather ensemble,
Fire Island, 1968

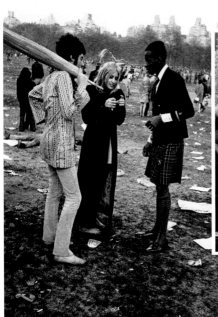

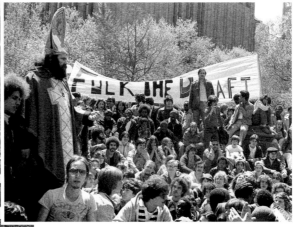

In retrospect, the New York City of the mid-1960s looks refreshingly more personal and immediate than today's media-driven metropolis. It was a pre-social media moment, when fashion trends were predicted by seasoned journalists and publicly debuted in artfully illustrated paper-based magazines. The city pulsated to its own beat; the streets were filled with music—from transistor radios, guitars, harmonicas, congas, flutes, voices singing, chanting, raised in protest. Clothing became masquerade, Central Park's Bethesda Fountain a costume party, weekends a perpetual Halloween brimming with thrift-shop scarves, 1930s bias-cut velvet dresses, peasant embroidery, tie-dyes, leathers, and fringes—all accentuating gesture and motion. The East Village was filled with rock stars and their leather-clad wannabes, replete with Superman T-shirts, Native American silver jewelry, and groin-skimming studded jeans. St. Mark's Place was theater, clothing was costume, and skin was canvas for body paint. It was this New York City that, as a commuting student at the Fashion Institute of Technology, Stephen Burrows embraced as *his* city. This was the way it was when Stephen Burrows fell in love with the city, its passion for life, and its inspirational potential. The creative energy of late 1960s New York would proceed to nurture him, inspire him, and impact his designs for the following five decades.

As the nation's fashion capital, New York City had entered the 1960s with an attitude toward dress that was far from relaxed. The fashion industry largely followed the directional mandates issued by the French haute couture and the American design hierarchy. The public relied on newspaper columns, magazine photographs, fashion editorials, and television wardrobes for its updates on trends and gossip. Saks Fifth Avenue, Bergdorf Goodman, Henri Bendel, Bonwit Teller, Lord & Taylor, Franklin Simon, and B. Altman—the temples of high fashion that solidified New York City's status as rival to the supremacy of Paris fashion—interleaved prêt-à-porter exact copies of Chanel and Dior couture originals with their own store-labeled "interpretations" and designs by post-WWII New York designers. With this blend of high-end options catering to society's upper echelon, those of middling finances shopped at Macy's Herald Square, Gimbel's, Stern's, and Orbach's for fashionable alternatives. Cut-price clothing and accessory jobbers S. Klein on the Square, Lane's, and Loehmann's lured a broad cross-section with the prospect of scoring a clothing treasure for a fraction of its original cost.

With few exceptions, New York's post-war fashion scenario moved predictably along—only to be jolted into the 1960s by the modernist approaches of such mold-breaking French

designers as André Courrèges and Pierre Cardin (with his 1964–66 "Space Age" collections) and American Rudi Gernreich (with his 1964 topless bathing suit). Breaking with traditions and time-sanctioned cuts, their modernist clothing skirted over the body from shoulder to hem, like the cookie-cutter dresses on paper dolls. Concurrently, the London-based British fashion invasion introduced sleek, distinctive looks that blended sophistication with naïvety. The Carnaby Street and Mod looks lifted traditional British tailoring techniques and incorporated them into the design of clothing with younger, hipper silhouettes. The styles were fed to an eager public, which gleaned fashion tips from the looks of lead characters of such mid-1960s British cult TV programs and feature films as *The Avengers* with Diana Rigg in her inimitable role as Emma Peel (1965–68); *Blow Up,* Antonioni's surrealistic vision of fashion photography (1966); and the Beatles' archetypical 1964 *A Hard Day's Night*. The fashion industry, banking on the marketability of these innovative garments, quickly produced line-for-line copies as well as stylistic interpretations in such profusion that, seemingly overnight, Courrèges's iconic *Mondrian* dresses had homogenized all class and age distinctions.

At the same time, a subculture of political activists—students, artists, and intellectuals—from both the East and West Coasts mobilized against the escalation of the United States' involvement in the war in Vietnam, against the military-industrial complex, and against the culture of consumption that they identified with the nation's affluent elite. The New Left quickly became a cultural— and a fashion—phenomenon as well. Equating the outrageous prices and flagrant materialism embodied by the haute couture system with the financial spoils of war profiteering, they rejected high-end clothing, showy jewelry, elaborate salon hairstyles, and costly fragrances. They embraced an unfamiliar new fashion lexicon, born of and unique to the spirit of antiwar radicalism; as protesters, they decided to *wear* their politics.

The new styles readily distinguished the counterculture from the mainstream and, in effect, provided its members with a uniform that reflected their political beliefs. Characterized by the adoption of old-world values and artisanal techniques, it underscored personalization, hand work, and long-spurned ethnic designs. In addition to stimulating home-produced cottage trades, this fashion backlash piqued an interest in the city's more remote corners as potential clothing resources. Intrepid individualists scouted out obscure but still surviving ethnic purveyors scattered throughout the city's long-established Middle-European enclaves. A wave of brightly

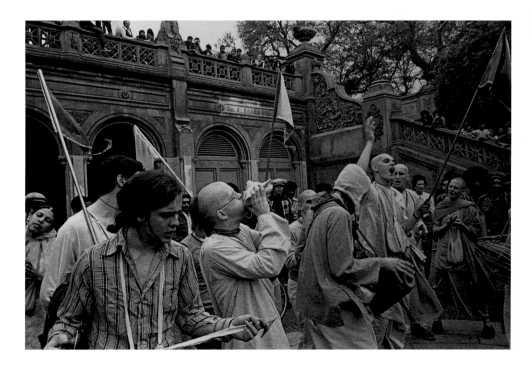

embroidered Polish, Ukrainian, and Mexican peasant blouses hit the streets, along with dyed sheepskin and Mongolian lamb coats, vests, and hats.

Not since the Bohemian culture that first evolved in Greenwich Village during the 1910s and '20s had an equivalent prescription for handcrafting, hand-dyeing, and surface embellishment been so embraced. Discarding tradition and the aesthetics that had long guided western fashion, this counterculture invented its own renegade style. T-shirts, pants, jackets, hair, and makeup all served to define the wearer's personality, political dogma, and social set. Hand-stitching and embroidering as a means of personalizing clothing were only the beginning. The art of tie-dyeing underwent a renaissance, its popularity increased by the model of Woodstock's highly visible musicians. A new focus on the therapeutic and energizing nature of color—red for basic energy, creative energy, and warmth; orange for nervous energy; yellow for intellectual energy; all seen as positive colors—added a new dimension to the artistry that had earlier drawn Village bohemian practitioners to the craft of dyeing in the 1910s. A return to the art of "kitchen chemistry" found aspiring teenage designers scouring local Woolworth stores for highly sought-after boxes of purple Rit fabric dye. Myriad-colored, slogan-emblazoned, appliquéd, and studded T-shirts became the uniform of downtown, uptown, and those attending "be-ins" and antiwar rallies on Central Park's Sheep Meadow.

The pursuit of alternative fashion drew a generation of individualists to New York, who stalked the alley-wide shops and exotic importers that sprouted up on a weekly basis throughout the city. Downtown, boutiques and head shops developed distinctive personalities by incorporating creative interiors, theatrical lighting effects, customized soundtracks (the Doors, BeeGees, Moody Blues, and Hendrix caused even R & B-devotee Stephen Burrows to listen), incense and fragrances, and especially their one-of-a-kind and limited-edition clothing. Uptown, Madison Avenue's Paraphernalia boutique was a hatchery for a radical group of locally based pop fashion designers—its interior was more closely akin to that of an art gallery than a dress shop. To complete the with-it look, Vidal Sassoon's

hair salon softened the stark precision of its signature cuts to make way for its layered "shag" look (perfected in 1968 by Sassoon himself for Mia Farrow), while the innovative cosmetics of Mary Quant—the so-called doyenne of English mod—could be found at her Bloomingdale's Mews shop, which featured wildly colored eyeshadows, leg paint, and eyelashes-by-the-yard. Lexington Avenue offered the custom-stitched leathers of the Stitching Horse, as well as an uptown branch of Different Drummer. The Upper West Side's longstanding artistic liberal community begot such lucrative establishments as Creations 'n Things, which paired lively new fashion finds with modern lifestyle merchandise, and the groundbreaking Charivari, which opened on Broadway and 85th Street in 1967 and introduced

Opposite:
Laced chamois shirt with fringed patchwork leather pants, ca. 1968

Top:
Stephen Burrows sketching, ca. 1970

Above:
Stephen Burrows, Pat Cleveland, and Charles Tracy at the West Side apartment of friend Roz Rubenstein, ca. 1970

locals to a new breed of cutting-edge talent. Closer to home for most radical dressers, the West and East Villages were replete with hand-embroidered, mirrored Middle-Eastern dresses and rough-hewn leather accessories. So-called head shops offered an array of fragrances as well as candles, incense burners, pipes . . . and the ubiquitous water buffalo sandals.

New York's most radical dressers also haunted alternative sources outside the norm for street wear. Hudson's, an Army-Navy extravaganza located on Third Avenue and 13th Street, offered a full array of navy pea coats, khaki and denim work shirts, steel-toed work shoes, and perhaps the broadest selection of jeans in the city. Known for its boggling range of ethnic clothing and accessories, Azuma on West 8th Street featured hand-block-printed cotton Indian floral bedspreads, so inexpensive and versatile that they inspired even those who had never sewn to try their hand at cutting full-length prairie dresses. Favorite accessories, affordable even on the extremely limited budgets of most shoppers, included jingling silver ankle bracelets, silk scarves, water buffalo sandals, and a wide assortment of meditative white and colored kurtas—traditional attire in Afghanistan, Pakistan, Nepal, India, Bangladesh,

and Sri Lanka, but street wear in the Village—popularized by the Beatles and Donovan.

A clothing-stalker's paradise, 8th Street stores offered a staggering selection of lace-up, over-the-knee, and western and Frye boots. For shoulder bags and sandals, the foremost emporium on the strip was Fred Braun. Braun's instantly identifiable matte brown leathers were everywhere, most especially its signature snub-toed, hobbit-type shoes, bags of all sizes, and coveted customized sandals. These were individually molded to the foot and could resolve to such extremes as the over-the-knee cross-lacing incarnation that Janis Joplin adored. Featuring exclusive, limited-production fashions, Et Cetera lured those who desired to see, if unable to afford, the work of experimentalist designers whose distribution was limited to boutique-scale establishments. The original Fred Leighton store occupied two stories on MacDougal Street, south of its intersection with 8th Street. Best known for its intricately embroidered hand-tucked Mexican wedding dresses and traditional peasant blouses, it also offered handwrought silver jewelry and ornamental tin lighting fixtures. Farther down the street was C'est Magnifique, a jewelry treasury filled with its ubiquitous poison rings and antique-style necklaces. For "Everything in Hip Gear," including the broadest range of T-shirts available in the West Village, consumers "trucked on over" to one of Naked Grape's two Village locations. Studded leather, originally marketed as motorcycle gear, as well as fringed leather and western boots also made their way into mainstream-radical fashion.

In an era challenging assumptions about gender roles, the clothing stores of the West Village became favorites for unisex skintight jeans. Different Drummer offered a rainbow of the lowest-cut, widest elephant bell jeans produced by Landlubber and Wrangler. Custom leather stores with their ground-length fringed, intricately laced jackets and membrane-tight pants provided rockers and civilians alike with their street battle gear.

Drawn to the high caliber of professional instruction offered by the Fashion Institute of Technology, Stephen Burrows landed in New York City at the apogee of its youth culture. He later recalled the spirit of the city at the time: "It was the budding of the flower children. I mean, Janis Joplin was the biggest thing, and the Age of Aquarius was

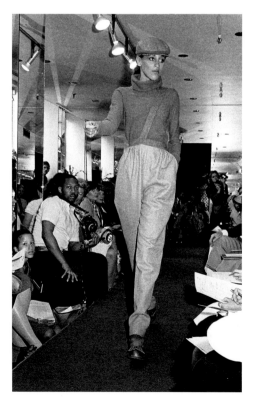

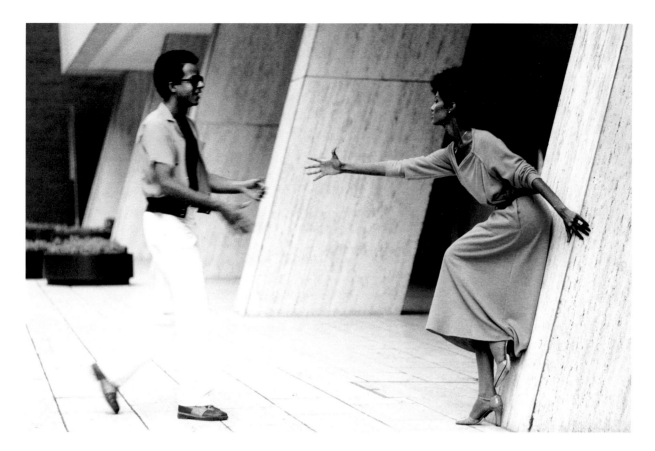

Opposite:
Alvin Chinn models sportswear by Stephen Burrows, 1978

Above:
Iman, in blue wool jersey dress with asymmetrical neckline, with Stephen Burrows, 1974

Following Spread:
Model Aria in Stephen Burrows, 1978

coming, it was the dawning of the Age of Aquarius. And it was all about caftans and flower children and love everybody . . ." Burrows found himself at the vortex of a radical revolution in dress. He and his classmates pooled their creativity into a communal existence, one that revolved around designing fabulously inventive clothing and dressing up in it. Sewing out of the East 7th Street apartment he shared with other FIT students, Burrows devoted himself to dressing his companions: "I was into leather and jersey, so all these people wanted clothes, and they would come over to the house, and we ended up with twenty people in my house putting on my clothes and then we'd all go out. I'd never see the clothes again, but I didn't care because after I wore them once I was over it." For Burrows, his clothing lived in the moment—much like the city itself.

The Age of Aquarius and psychedelia heralded the birth of an unprecedented color palette. Explosive oranges, Day-Glo greens, garish pinks and magentas were all worn without the slightest thought about rules that had traditionally governed the combining of color; the goal was to absorb their energy and radiate it back for all

onlookers. Stephen Burrows caught this explosion, assimilated it, and channeled it into sensuous garments that playfully wrapped the body in pure, vibrant color. What began downtown as a visionary, small-scale designer building a discrete cult following rapidly leaped into full-blown commercial production as Burrows's revolutionary clothing vision ignited the general fashion public. The unbridled energy that infused his early creations as O Boutique's cult-designer (1968–69) later surged into fashion's mainstream when Burrows joined Henri Bendel in 1970. There, his debut collections featured vivid jersey color blocks and tightly fitted, studded leathers that directly reflected his East Village sensibility. Although he proceeded to simplify his approach to feature linear, monochromatic design, more explicitly sensual women's wear, and lighter fabrics (notably chiffon-weight, matte Jasco jersey embellished with his signature lettuce edges), his work always maintained the lighthearted spirit that had characterized it from the beginning. Even when forms took new directions, the colors, freedom, and danceability of the 1960s never left Stephen Burrows's work.

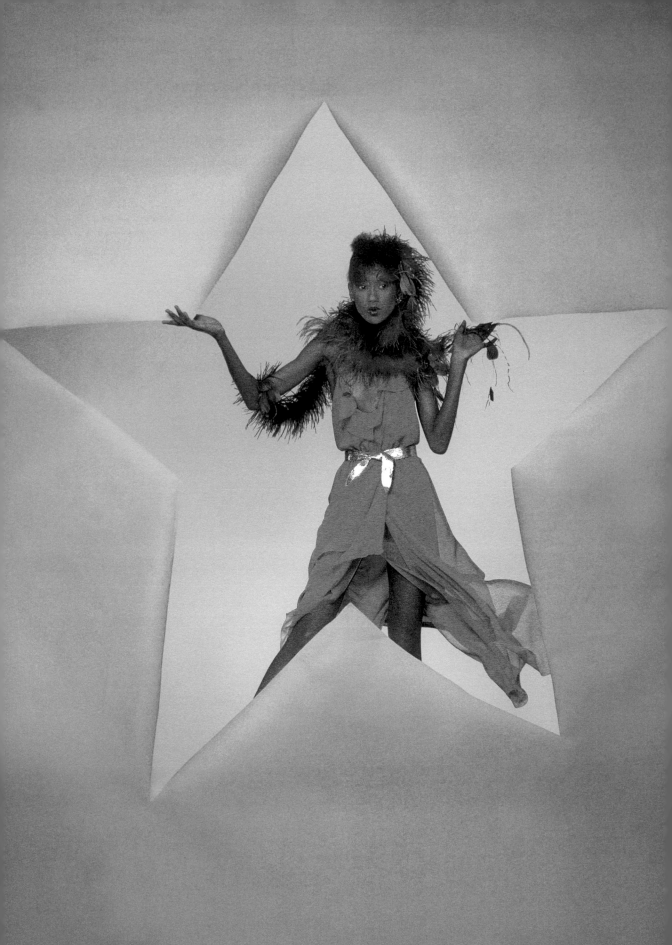

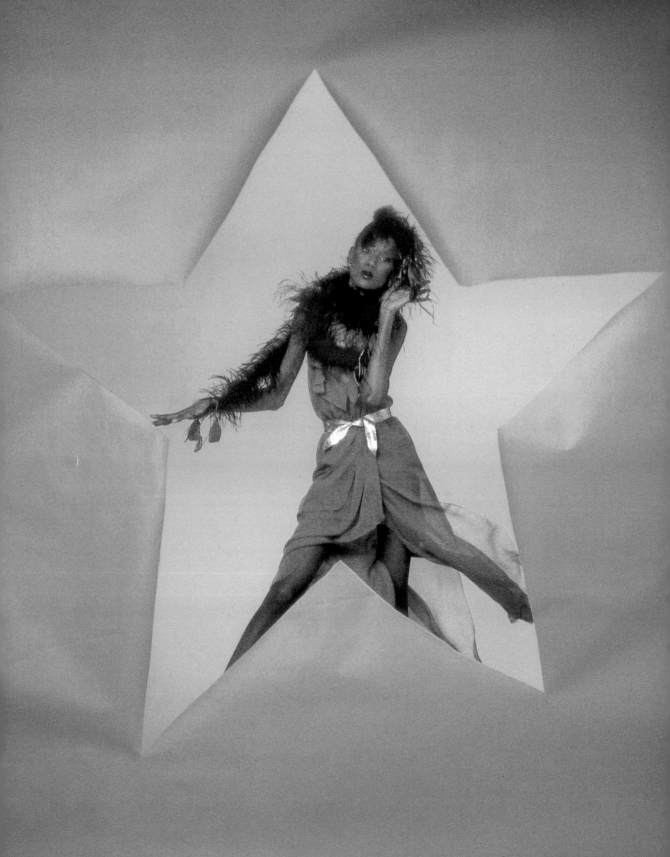

ASCENDING TO FREEDOM

DANIELA MORERA

For someone like me, landing in New York in 1969 from across the Atlantic was to experience at once grandeur, abundance, rhythm, and freedom.

Two pages from "T Shirt" editorial in *L'Uomo Vogue*, 1978, featuring New York cultural figures. (Top) Stephen Burrows and friends. Back row, left to right: Laryssa, Andre Cinandre, unknown, Bethann Hardison, unknown, Stephen Burrows, Touki Smith. Front row: Apollonia, Ara Gallant, Candy Pratt, Willi Smith, Barry and CeCe Kieselstein-Cord. (Bottom) Andy Warhol and his "Factory." Back row, left to right: Robert Hayes, Todd Brassner, Catherine Guinness, unknown, unknown, Richard Bernstein, Vincent Fremont. Front row, left to right: unknown, Kevin Farley, Gigi Williams, unknown, Ronnie Cutrone, Andy Warhol, Shelly Fremont, Bob Colacello, Walter Steding.

Everything was of gigantic proportions: the architecture; the number of people walking up and down the avenues and subway stairs; the department stores flooded with merchandise beyond the imagination; the lofts and the art galleries in SoHo; the modern museums; the helicopter to and from JFK on top of the Pan Am Building; the smell of exotic foods; the constant, thunderous acoustics of the streets with people of different ethnicities at every corner. People were dressed in so many different styles (or no style), a métissage that I had never experienced before.

I arrived as a young model from the *alta moda* runways of Rome. There were only three young American designers for me in the late 1960s and early 1970s (until I discovered "the one," Stephen): Calvin Klein, Halston, and Giorgio di Sant'Angelo. Calvin was for sportswear and a new approach to wearable good taste, sometimes with an eye to the French ready-to-wear. Halston embodied chic with a freshness that was unique among American designers, who were often still confined by the European tradition. Sant'Angelo offered a gypsy, hippie, multiethnic potpourri that was a visual extravaganza—for those who could afford it.

But when I experienced Stephen Burrows, it was a total revelation. He was the only one with for-the-street-and-from-the-street dynamism. New York's streets had a magic that I was discovering every minute, always whirling with energy and illuminated by a new light. The force of the street moved with the wind of a new way of life that Stephen Burrows had the imagination to ignite with his fashions. Living in the most unbelievably creative utopia, Burrows had those

Below:
Acclaimed drag queen Potassa, in an off-the-shoulder dress with zigzag finishing by Steven Burrows, at Studio 54, 1977

Opposite:
Models Bethann Hardison and Daniela Morera, with Stephen Burrows at a party for designer Valentino at Studio 54, 1977

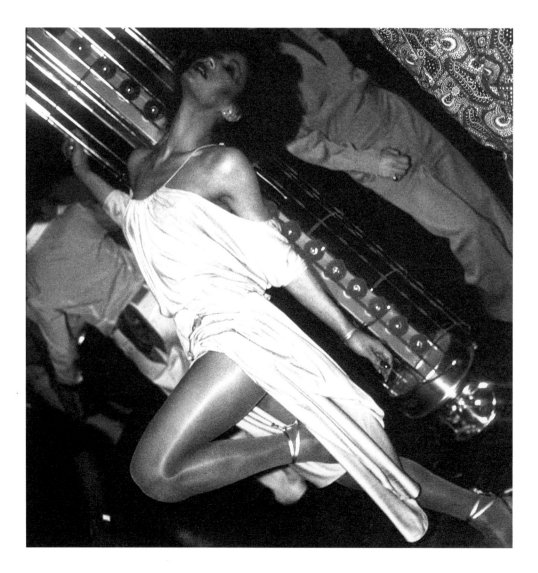

STEPHEN BURROWS

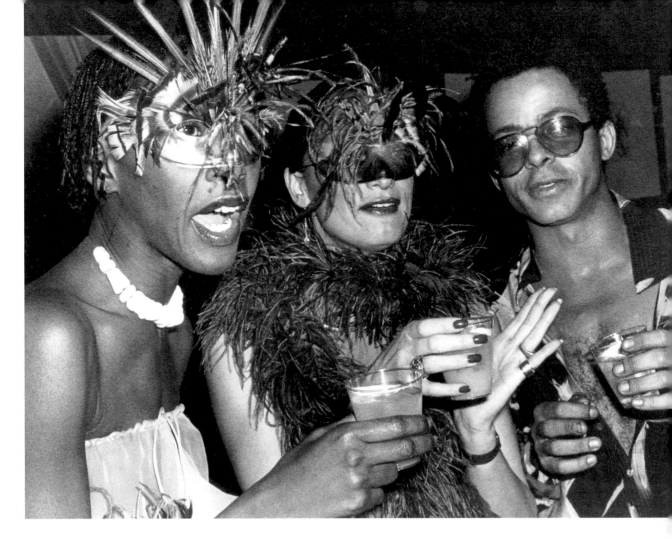

special antennae to capture the vibrations of his time and become one of the protagonists of the new Manhattan style, just as Andy Warhol had done in the arts, and all those in that talented music crowd.

Every second, I inhaled a sense of freedom. The city emanated a sense of vitality, of electricity, that was pervasive. Stephen Burrows and his clothes were the embodiment of that special lightness of being that surrounded me. His creations, worn for wild nights filled with disco music, possessed an attractive quality, the exact opposite of apotropaic (from the Greek *apotrepein*, meaning "to hold at a distance" or "to keep away"). They were exactly like the music itself, that enveloping, cocooning sound: sexy, sensuous, visceral vibrations. His clothes' chromatic and moving qualities not only captured attention for the wearers, but also electrified the onlookers, adding to the energy on the runway or the dance floor. The women

who chose these kinds of clothes emanated the same shared aura, joining them together into an implicit community—the "commune," the hedonistic assemblage. They had an innate, magic spontaneity imbued with an allure, a posture, a sex appeal, a desire to break the rules, to have fun. They were ready: snap, snap, snap . . . free! (No linings, no buttons; just snaps and ties.) Ready to climb the walls of freedom.

He was an innovator, making:
active, athletic looks before anyone else
wrap dresses before Diane von Furstenberg
metal mesh dresses before Gianni Versace
deconstructed clothes before Giorgio Armani

My evenings were flooded with cocktail parties, where people had a very open attitude, and where the people were more eclectic than the ingredients in the drinks. Young talented people were everywhere. "I'm an artist, I'm an artist,

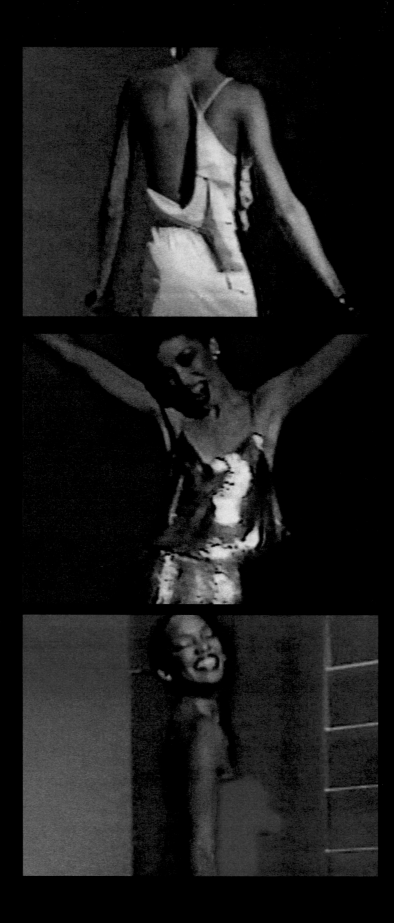

I'm an artist" was the mantra I heard nonstop at night (artists sleep during the day). A group of young and gorgeous actors who were appearing in *Hair* Off-Broadway—I presume that I met them at some party—one day rang my doorbell unexpectedly asking if they could take a shower. In Italy, we were so old-fashioned bourgeois that we still went to visit someone for tea or a drink with a previously arranged appointment. I was amused. Hippies! This was New York: shocking in any sense.

The difference between uptown and downtown sometimes felt greater than the distance across the Atlantic. From Park Avenue to Max's Kansas City and later the Mudd Club—a world away, but all in the same city. Fascinating! Max's was where Andy held court every night with his Factory entourage. Across the street, Stephen opened his O Boutique. *O*, the Japanese symbol of eternity, lasted only a few seasons in Manhattan's vortex. Music was everywhere, and every night there was dancing, dancing, dancing. We were living in a constant crescendo.

Margot Fonteyn once wrote that Marilyn Monroe's gestures "were reflected throughout her body, producing a delicately undulating effect like the movement of an almost calm sea." Burrows's bias and round cuts instead allowed bodies to move with the grace, the fluidity, and the quickness of reptiles. Naomi Sims, Pat Cleveland, Alva Chinn, and Iman were the incarnations of that spirit. A new inspiration, a new body, a new body *language*. A new freedom born from experimentation beyond the imprisonments of our past experiences. The body, Stephen's body, moved in a different way. Not only the girls but everything around Burrows moved with an almost antigravitational suspension. The mutation had started. The lightness of his fabrics, the simplicity and fluidity of his clothes like a weightless veil over the body, with a magic touch and minimal details, represented the embodiment of a new femininity, a contemporary incarnation of the supreme beauty of Botticelli's *Primavera*.

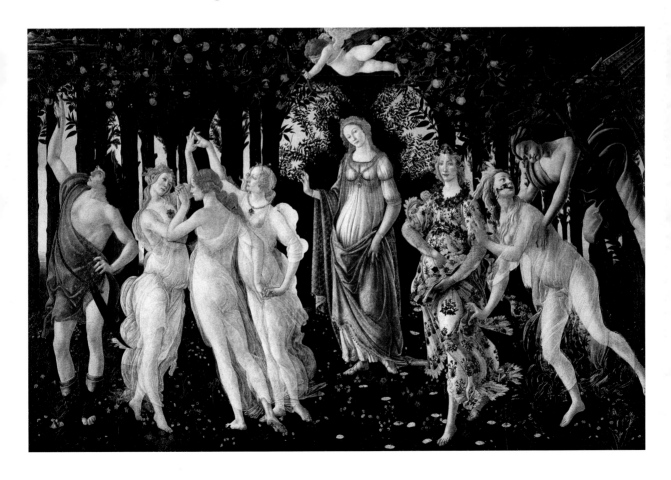

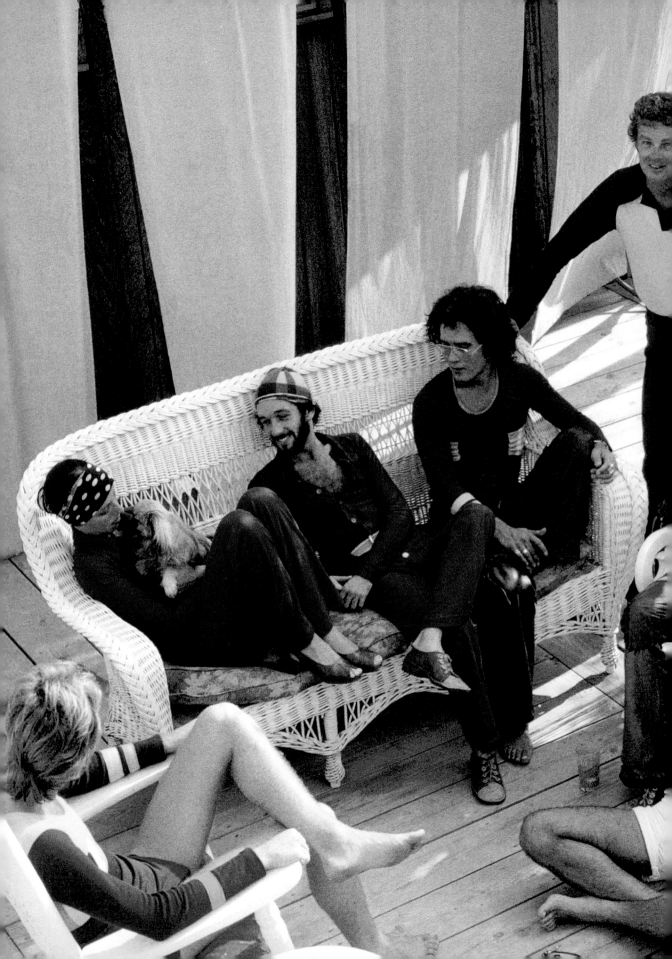

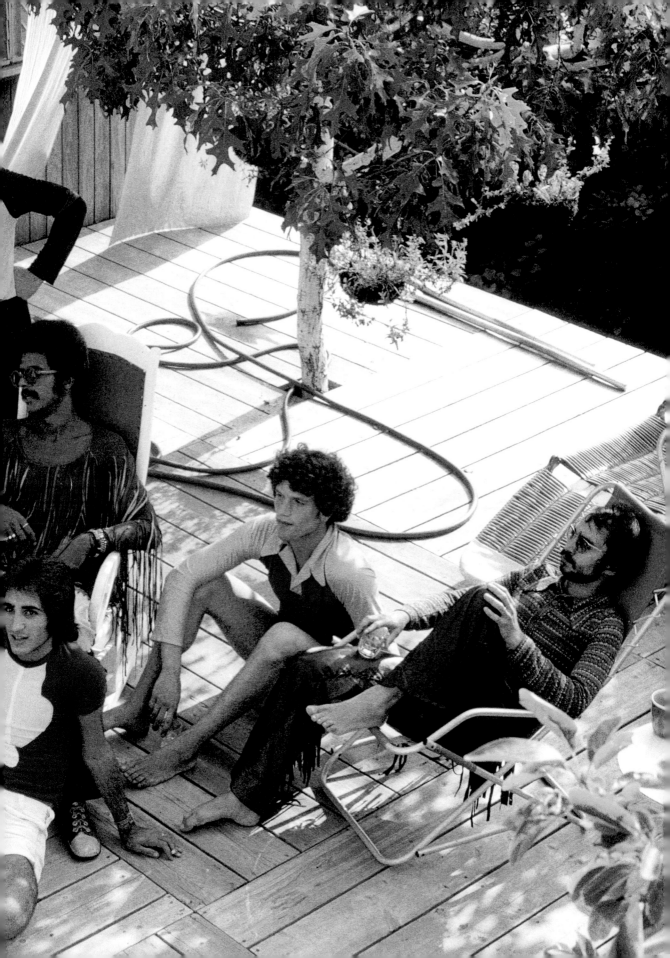

STEPHEN BURROWS'S WORLD BY NIGHT

GLENN O'BRIEN

When I arrived in New York in 1970 fashion was having a revolution. Hippie was over. Even cops had long hair, so cool young men had cut theirs short. People were no longer dressing up like gypsies or peasants— they were taking fashion into the future. Acid rock was burned out, and people were dancing to a funkier beat. New York was a mixed-up world of white, black, and Latino, gay, and straight, all bouncing off each other.

A fashion show at
O Boutique, ca. 1968

New, inspired, and gutsy designers were everywhere, especially downtown because everybody got dressed up to party every night. That's how these designers (especially Stephen Burrows) became designers—by dressing themselves and their friends for the night. Halston was the big fashion cheese of New York then, the first American designer to have his name up in European-sized lights, but that was the uptown world. The only people I knew who wore Halston worked or modeled for him and were able to borrow something. Kids wore young designers and stuff they cobbled together from thrift shops or made themselves.

Downtown there was always something livelier going on. It was gritty and dangerous and fabulous all at once. Rents were cheap and creative people

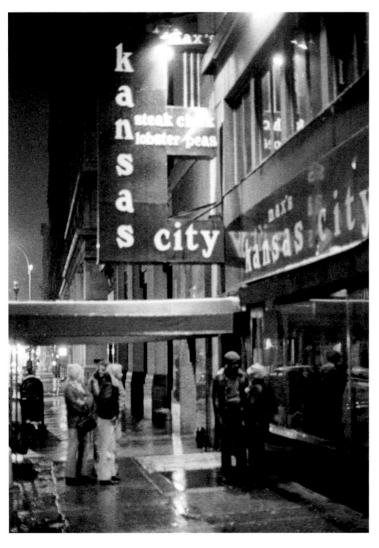

of all kinds flocked there. New York was the capital of the art world, the literary world, the theater world, and the dance world. It also happened to be the capital of the gay world. There might have been eight million people here, but in the creative community everybody knew each other, because we all went to the same bar every night.

I worked on *Interview* for Andy Warhol and each night our crowd assembled at Max's Kansas City, a restaurant and bar on Park Avenue and 18th Street. Actually it wasn't just our crowd, but *the* crowd, the creative community of New York. The art world sat in the front of Max's by the bar—artists like Robert Rauschenberg, John Chamberlain, Larry Poons, Carl Andre, Larry Rivers, Robert Smithson, Joseph Kosuth, Donald Judd, and Dan Flavin. You found music-business types sitting in the middle of the joint, honchos like Clive Davis or Steve Paul, artists like Tim Buckley, the Winter Brothers, or Bobby Neuwirth. In the back room, under the red light of a Dan Flavin fluorescent artwork, sat (though hardly still) a community of fantastic oddities, including the Warhol contingent (Warhol himself rarely went there after he was shot in 1969), the John Waters contingent, the Cockettes, Robert Mapplethorpe and Patti Smith, Alice Cooper, and Todd Rundgren, along with the artists too odd or young to hang out in front, like Ray Johnson, Marisol, and Brice Marden. Then there were the fashion people— the models like Jane Forth, Donna Jordan, and Apollonia van Ravenstein, or photographers like Chris von Wangenheim and Oliviero Toscani, hairdresser Ara Gallant, designers Jackie Rogers, Tiger Morse, Betsey Johnson, Fernando Sanchez, Scott Barrie, and Stephen Burrows. They were all big personalities, even the quiet ones. Stephen Burrows had an air of mystery about him. He sold his clothes across the street from Max's at the O Boutique where he was a partner, until he was scooped up by Henri Bendel and spirited uptown to his own boutique there.

Boys danced with boys, boys danced with girls, girls danced with girls, or you just danced with yourself, no problem. I remember dancing with Helmut Berger and Grace Jones the same night, at Le Jardin, the club that changed everything. It was located in the basement of the rather seedy Hotel Diplomat off Times Square— which also contained the Christmas Bar, where

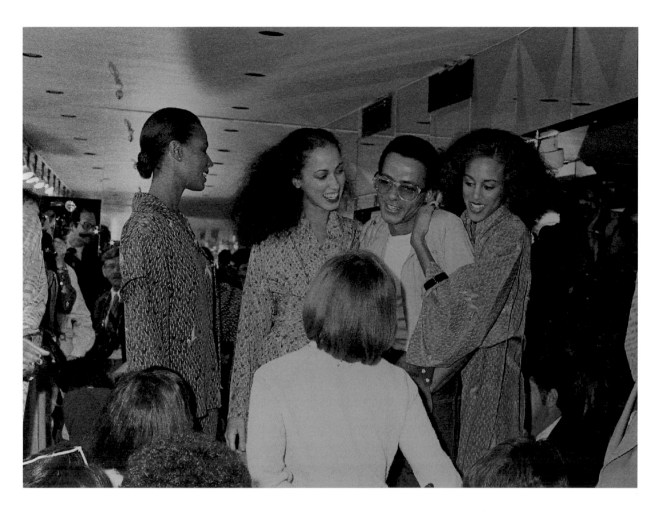

it was Christmas 364 days a year (they closed on Christmas day). LeJardin was opened in 1973 by club veteran John Addison, a former model. It was decorated in an upscale chic style with white furniture and palm trees, white mannequins holding white balloons, and it was the first dance club that more or less accepted chic straights to mix with chic gays. There was also a penthouse you could reach by private elevator, which is where people went to smoke . . . whatever. Addison hired the best DJs, taking Nicky Siano from the Gallery. A guy named Steve Rubell worked the door at LeJardin and he started to get ideas. In two years, he would be guarding his own door at Studio 54. The world was changing, pulse picking up, beats per minute from andante to allegro. The whole world was getting aroused.

Stephen's clothes were made for this type of dancing. In the 1970s, when the best music ever was being made, people went dancing every night, and they dressed for it. The gay clubs had the best DJs playing the best music for the best dancers, which is why the beautiful young women loved the gay discos (they also would not be hassled by strange men as they might even at the better straight joints like Hippopotamus or Adam's Apple). Some places, like Tenth Floor, didn't admit women—the guys there wore flannel lumberjack shirts and moustaches, and they were there to meet guys, not girls. But at many gay clubs, women were welcome, if they were the right type of women—hip, beautiful, good dancers, and friends with the boys. Sanctuary, a defrocked Baptist church near Times Square, put the DJ booth on the altar, and as the owner told me, "We painted the whole fucking thing purple." One of the first crossover places was Tamburlaine, a Chinese restaurant by day and a gay dance club by night with a fairly mixed crowd that included plenty of girls. The models brought in pretty boys and straight men could get in if they were cool or could pass. Actually, things were not all that defined.

I met Tuesday Weld there, and all the top models of the time hit that joint because the music was the best and the vibe was the coolest and nobody bothered them.

The girls who starred on the dance floors of those clubs were the girls who wore Stephen Burrows. A Burrows dress wasn't made to lean up against a wall in or sit in—it was made to twirl, leap, and undulate in, made to move. His dresses bloomed in motion, like a hothouse garden of orchids, like a Fillmore East light show. Some of the girls you would see lighting up the dance floors of the best clubs were the same girls who walked—or really *danced*—down the runway for Stephen. Beautiful girls like Pat Cleveland, Ramona Sunders, Alva Chinn, Elsa Peretti, Gloria Burgess,

"Tangerine" by Salsoul Orchestra, "Hot to Trot" by Alfredo De La Fe, and "Shining Star" by Earth, Wind and Fire.

Stephen was a witness and participant at Sanctuary, at Aux Puces, at the Loft, at LeJardin, at Rubell and Schrager's Enchanted Garden in Queens, at the Garage, at Studio 54, at Hurrah, and at Arthur Weinstein's after-hours joint, the Continental, not to mention Fire Island. Only a true survivor remembers all those clubs. Although his imitators might have received more credit, Burrows made the first disco dresses, bias-cut masterpieces that accentuated curves and amplified the drama of dance, and all in colors that looked like the future. When a girl put on one of those dresses, a party started around her. When it

Jennifer Brice, Norma Jean Darden, Bethann Hardison, Billie Blair, and Mounia. A Burrows fashion show was not like the shows you see today, where mostly white teenagers walk stiffly looking straight ahead, and appearing like they might fall over backwards. Stephen had a mixed cast of girls—white, brown, and black. They were all slim and pretty, and they glided and twirled down the runway to the music like it was the most enchanted party of all time. They danced to "Family Affair" by Sly & The Family Stone, "Let's Stay Together" by Al Green, "One of a Kind (Love Affair)" by the Spinners, "Boogie Down" by Eddie Kendricks, "Life and Death in G & A" by Love Child's Afro Cuban Blues Band, "Cherchez La Femme" by Dr. Buzzard's Original Savannah Band,

came to music, Burrows was a fan of Motown, the Memphis sound, and the Philly sound. Burrows was a connoisseur of the good stuff. The great music of the time wasn't just a disco beat: it was rhythmically complex and exotic, and a floor of beautiful dancers moving together to the beat was a glory to behold.

Of all the visual creators of the time, whether in art or fashion, I believe that Stephen Burrows best captured the crazy, energetic, all-out feeling of the night when everybody danced, the times Chic was talking about in *Good Times*:

Happy days are here again
The time is right for makin' friends
Let's get together about quarter to ten
Come tomorrow, let's all do it again.

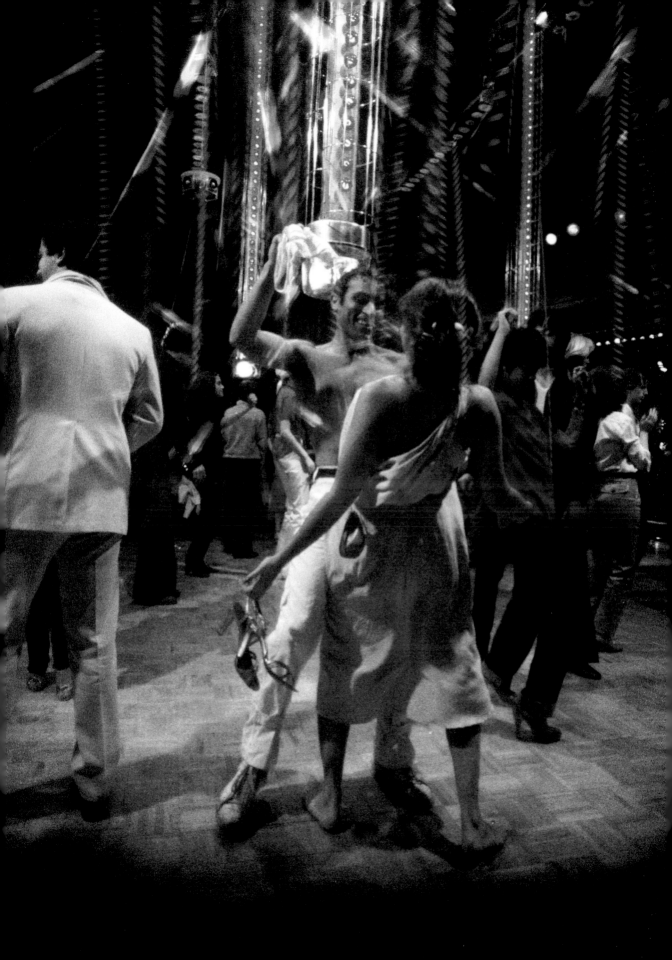

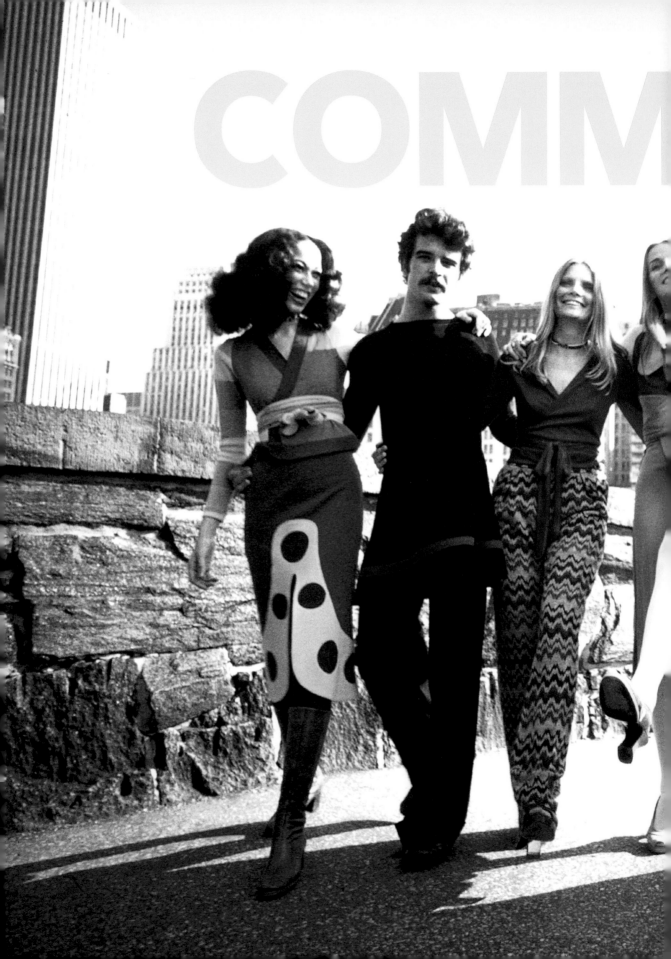

COMM

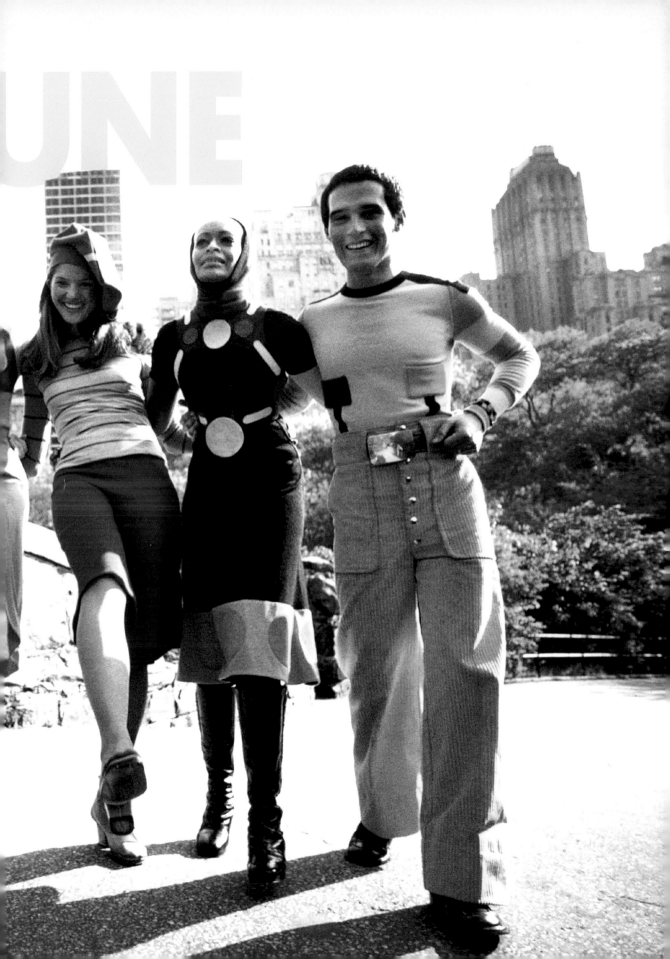

Previous Page:
Members of Stephen
Burrows's "commune"
in the first collection of
Stephen Burrows' World
for Henri Bendel, Central
Park, 1970

Stephen Burrows entered New York's fashion scene in the late 1960s with enthusiasm, energy, and a huge creative vocabulary to apply to his work. Having declared open season on fashion, downtown youth culture made experimentation its modus operandi, inaugurating a distinctive vocabulary of fabric, techniques, and finishing elements. A number of these particularly appealed to Stephen Burrows during his developmental period, when he designed for the small group of friends, models, artists, and fellow designers who made up his inner circle—the "commune."

In this early work, the designer was attracted to leather and suede, finding them seductively tactile and appealing as a medium. In Burrows's hands, the skins were fringed, slashed, patched, and whipstitched together as body-gloves, and pieces were often designed to be worn by both men and women. Burrows also made ample use of shiny, three-dimensional studs, abundantly applying them to enhance surface interest and reflectivity. His early patchwork pieces assembled snippets of leather and jersey, exploring the interplay of various colors, weights, and textures to create singular, lively garments. Although of a period, the work he produced from 1968 into the early 1970s was perhaps his most playfully naïve—but its creative core would inform his sexiest and most sophisticated looks.

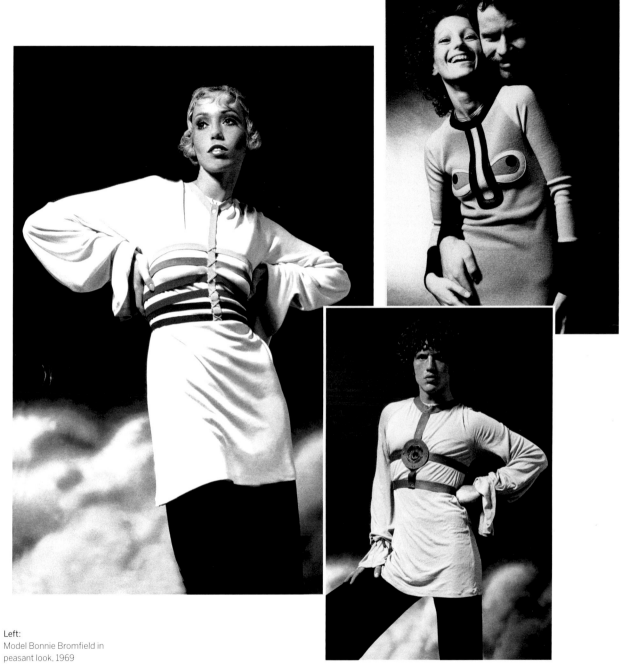

Left:
Model Bonnie Bromfield in peasant look, 1969

Right, Top:
Wedding portrait of Arleen Bowman in "cock-and-balls" dress with her husband, Bryce Bowman, 1971

Right, Bottom:
Burrows's friend Tony DePace in peasant look, 1969

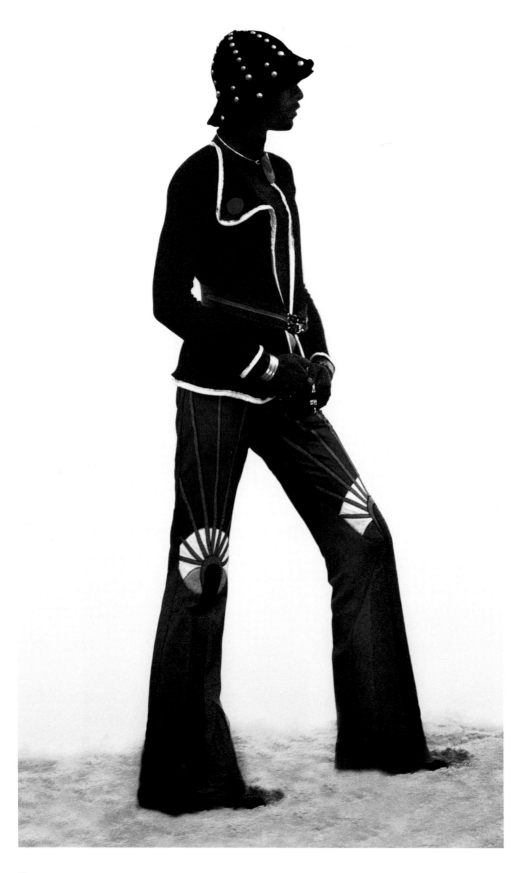

STEPHEN BURROWS

Opposite:
Stephen Burrows in knit
sweater with leather trim
and patchwork leather
pants from O Boutique,
1969

Below:
The commune in Fire
Island, 1969

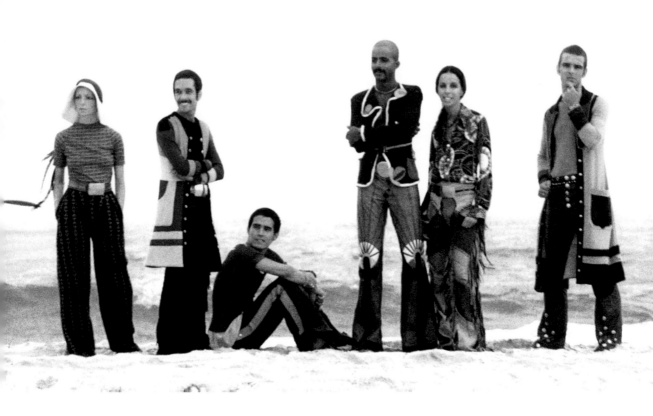

"O is a groovy haven for the beautiful people. Stephen Burrows, twenty-five, knows how to whip up sophisticated nothings as well as strikingly original clothes and accessories."

PATRICIA PETERSON,
The New York Times, May 25, 1969

Deanna Lambert in fringed dress, 1969

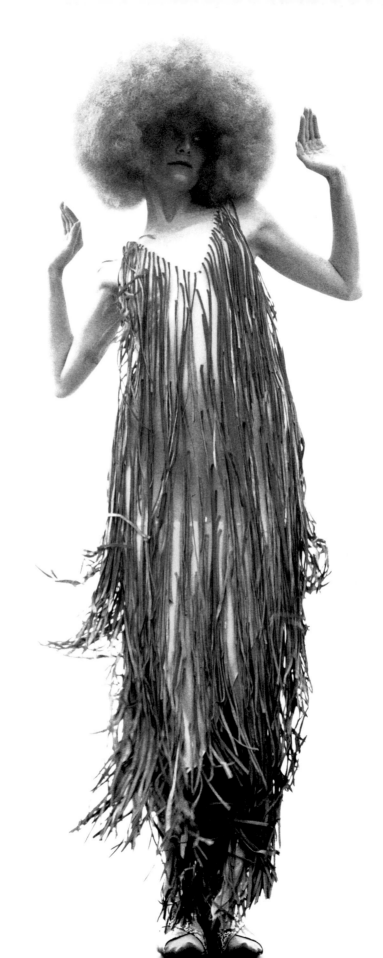

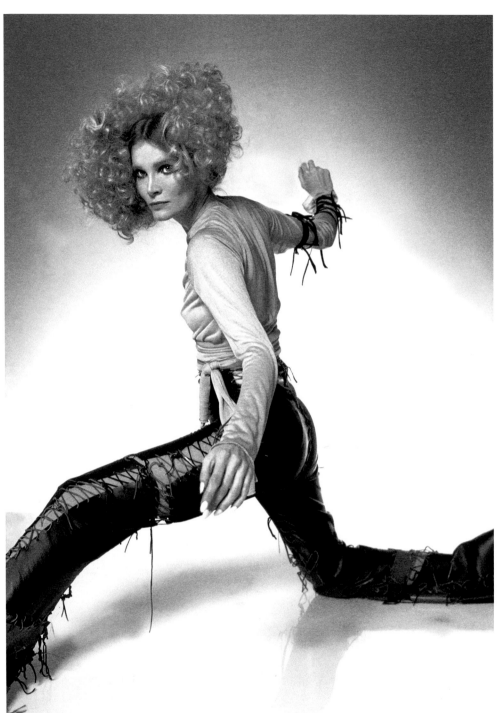

STEPHEN BURROWS

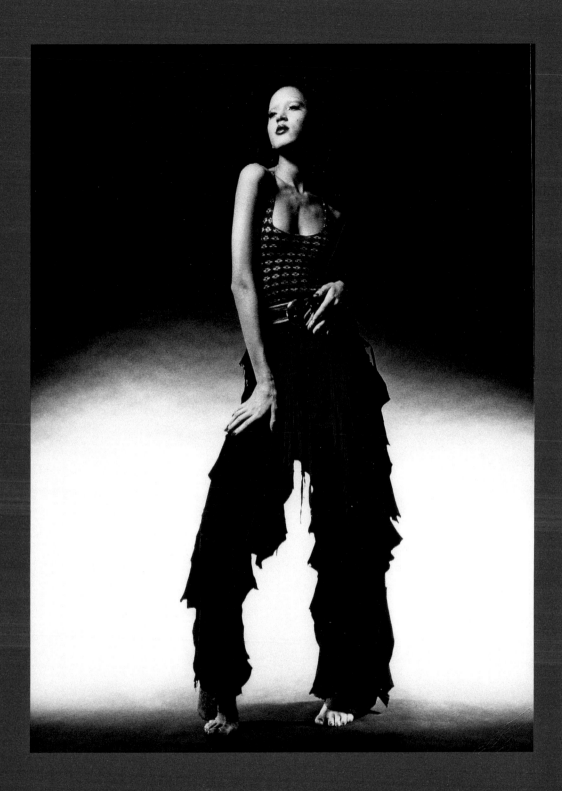

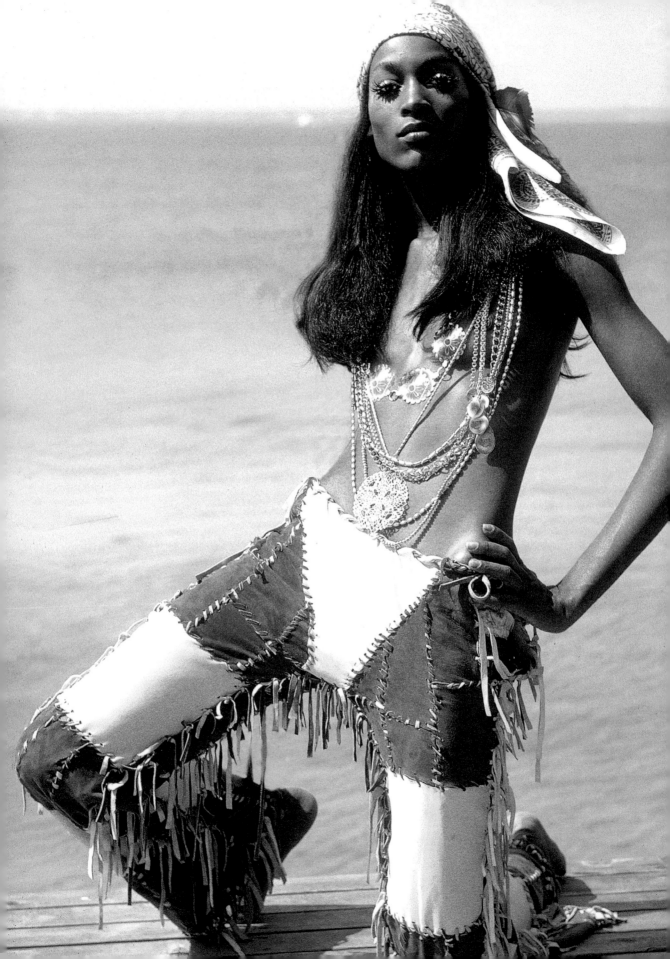

Opposite:
Naomi Sims in fringed leather pants, Fire Island; reinforcing the "any-sex" idea, Burrows himself wore these pants (see above), 1968

Above:
Stephen Burrows in flower-print shirt and patchwork leather pants on Fire Island, 1968

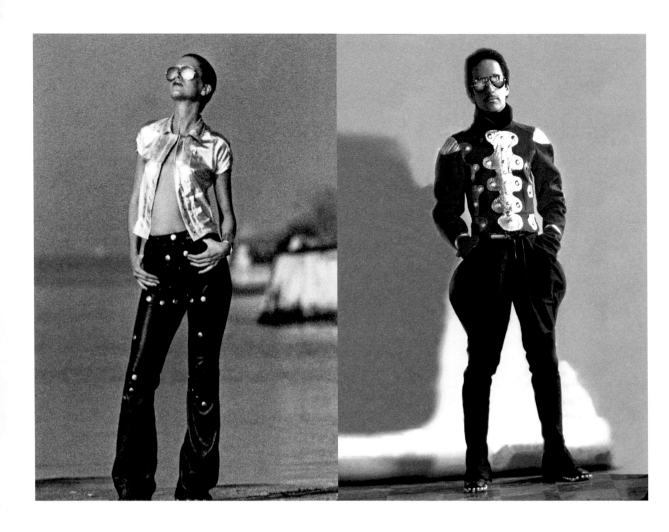

STEPHEN BURROWS

Left:
Elsa Peretti in studded
leather pants and zigzag
silver lamé top, 1972

Right:
Designer and friend Bobby
Breslow in wool melton
jacket with studs and gold
leather appliqué and jodhpur
pants, 1969

Opposite:
Models in studded any-sex
looks, 1969

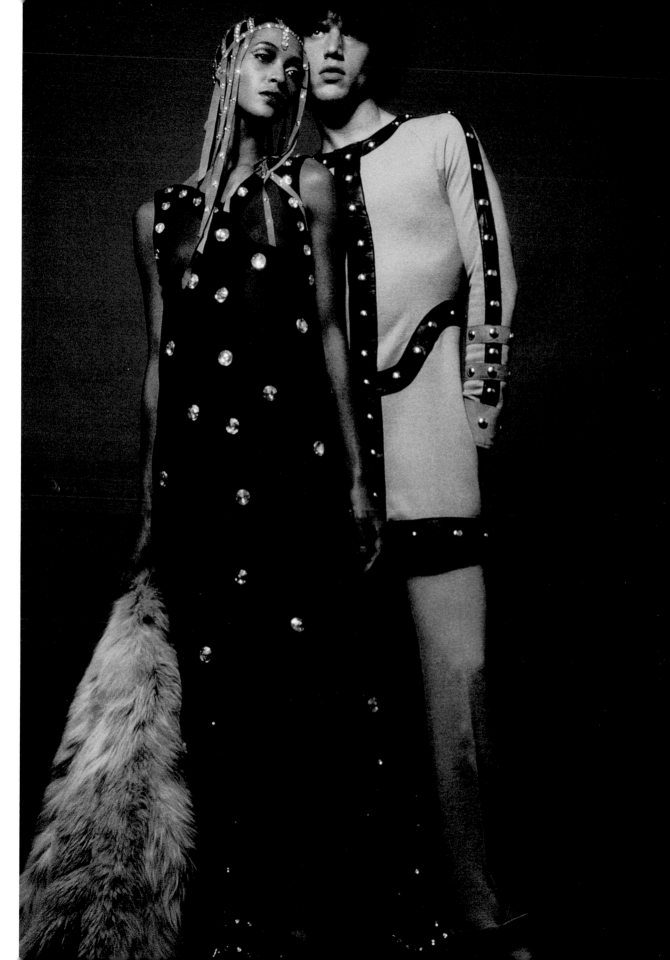

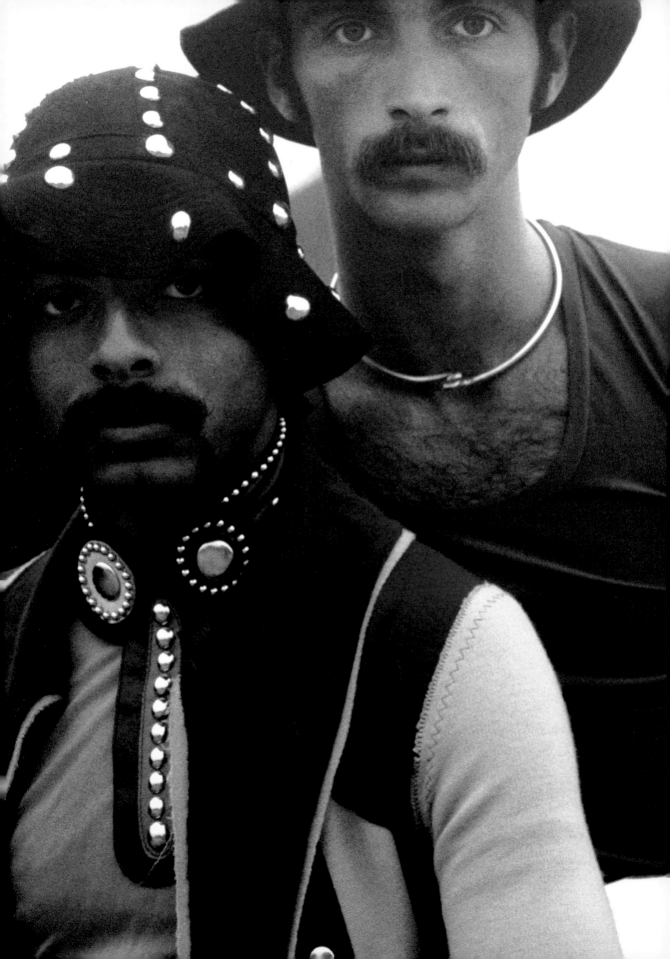

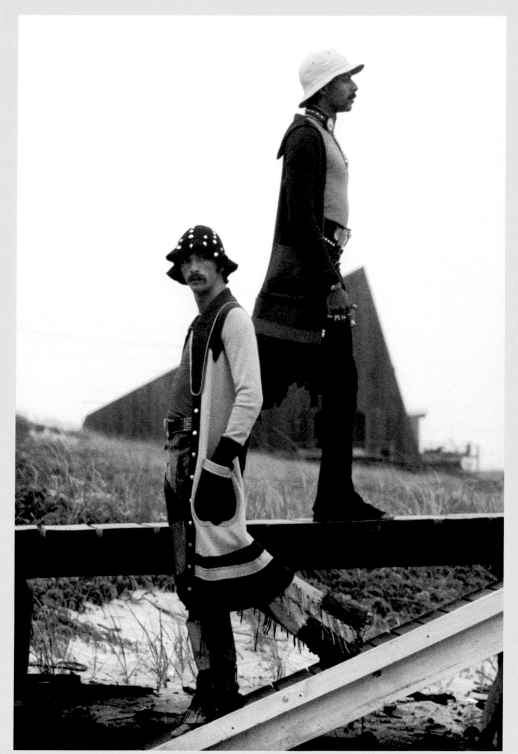

"Like any original, his clothes are controversial and I hope they always will be. Pro or con, attention must be paid to them."

GERALDINE STUTZ,
New York Post Magazine, June 16, 1972

Jersey dresses with studded leather tops, 1970

STEPHEN BURROWS

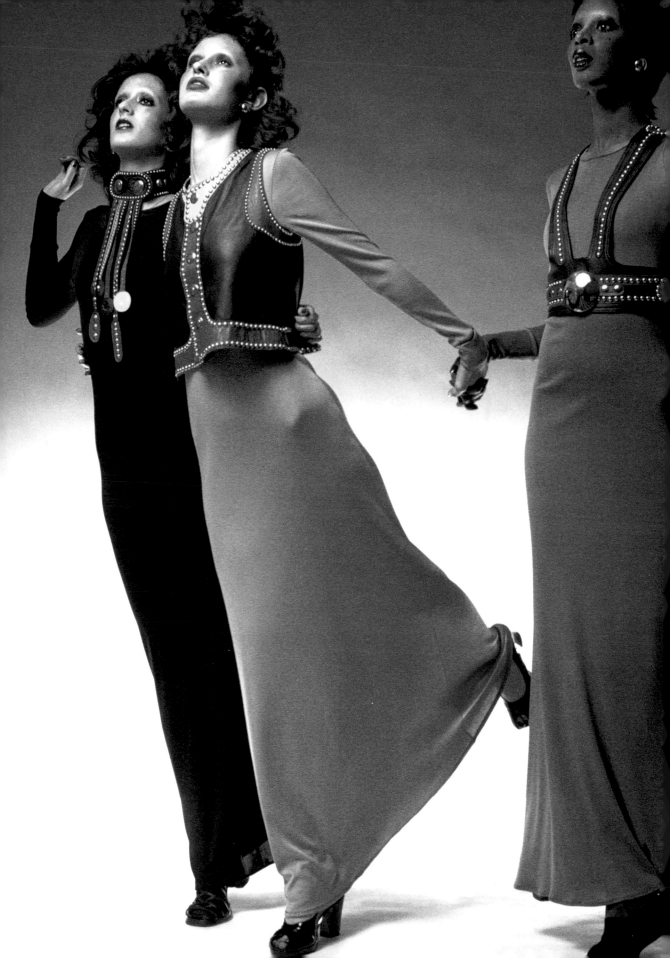

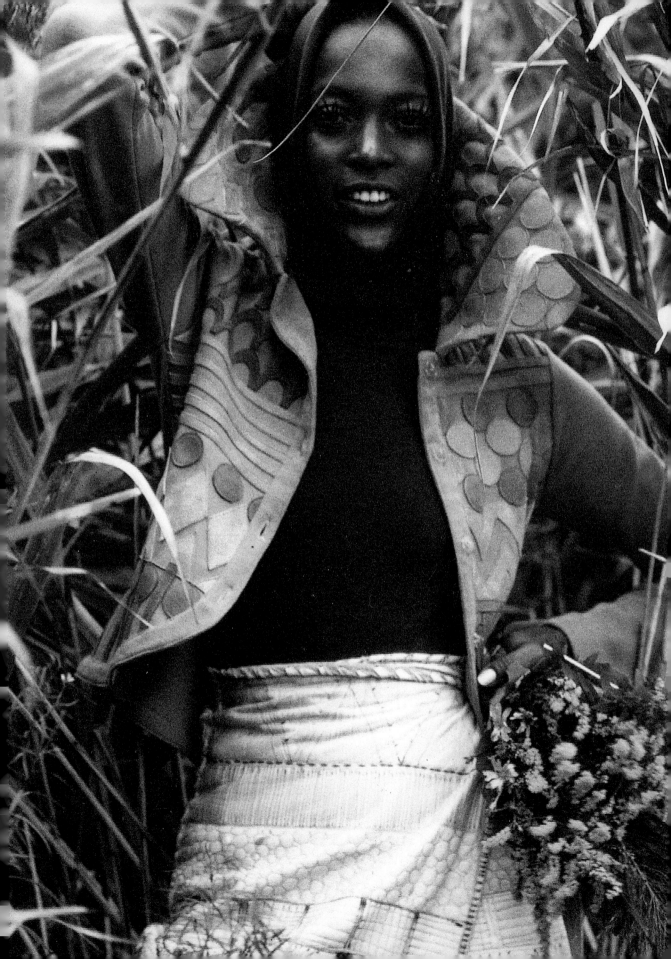

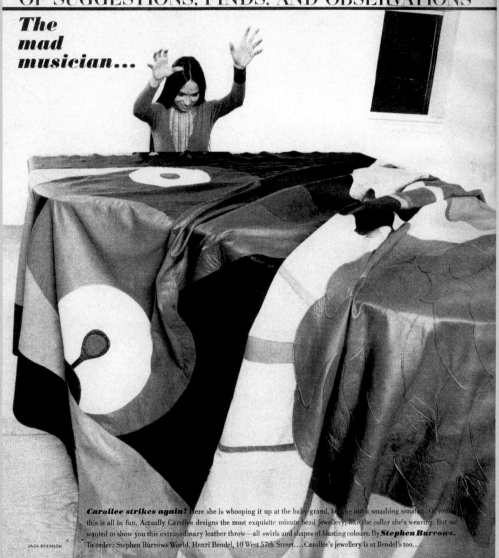

VOGUE'S OWN BOUTIQUE

OF SUGGESTIONS, FINDS, AND OBSERVATIONS

The mad musician...

Carollee strikes again! Here she is whooping it up at the baby grand, beating out a smashing sonata... Of course this is all in fun. Actually Carollee designs the most exquisite minute head jewellery, like the collar she's wearing. But we wanted to show you this extraordinary leather throw—all swirls and shapes of blasting colours. By *Stephen Burrows.* To order: Stephen Burrows World, Henri Bendel, 10 West 57th Street.... Carollee's jewellery is at Bendel's too....

JACK ROBINSON

Opposite:
Naomi Sims in suede appliqué jacket and etched leather wrap skirt, Fire Island, 1969

Right:
Bendel's jewelry designer Carollee playing a piano draped with Burrows's patchwork leather throws, 1970

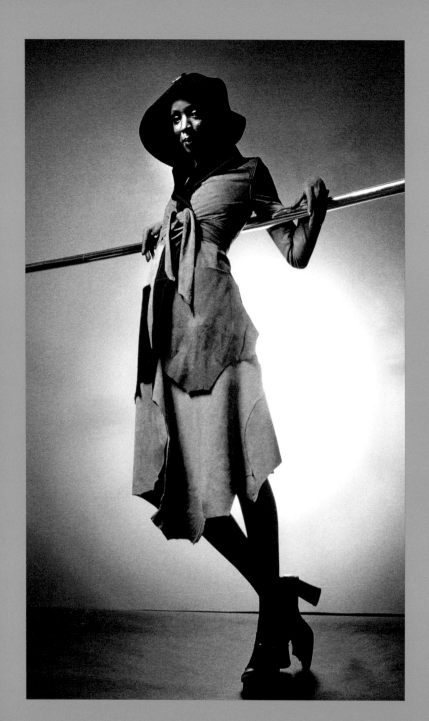

STEPHEN BURROWS

Left:
A patchwork suede
ensemble, 1969

Opposite:
Model Marina Schiano
in satin jumpsuit with
signature zigzag stitch,
Fire Island, 1972

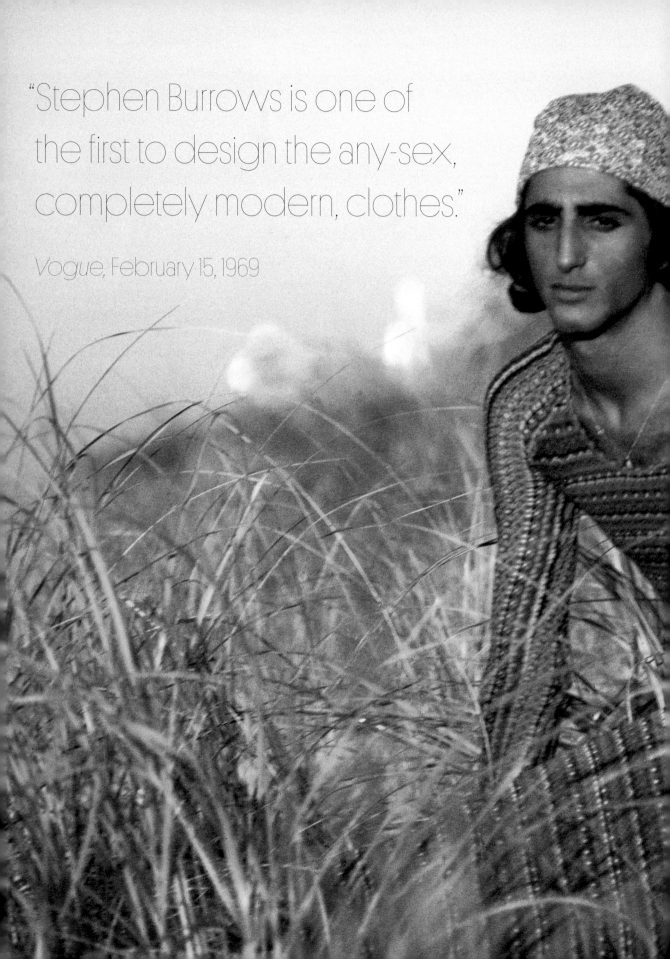

"Stephen Burrows is one of the first to design the any-sex, completely modern, clothes."

Vogue, February 15, 1969

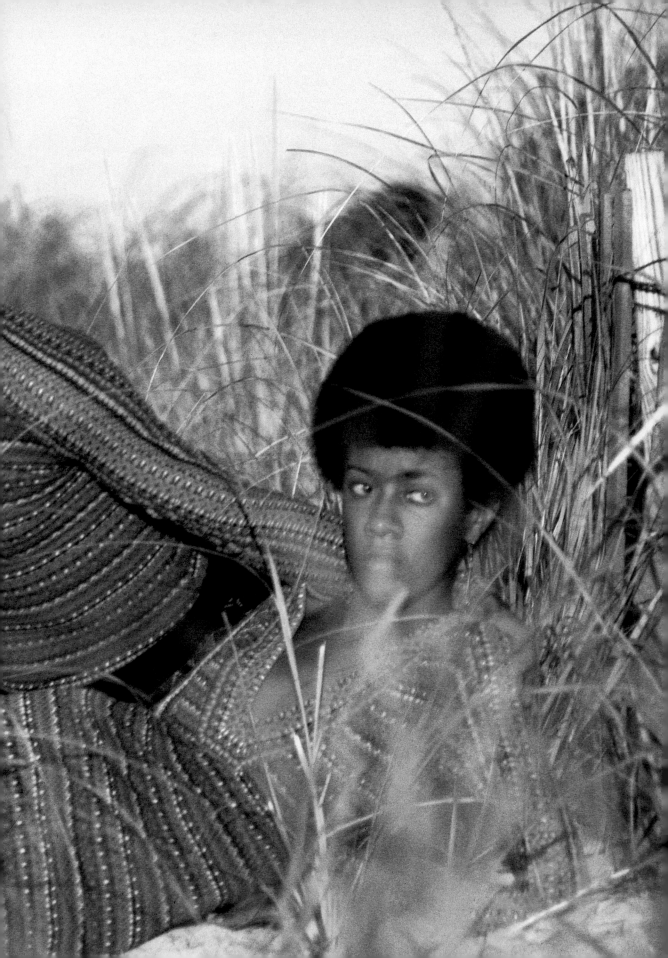

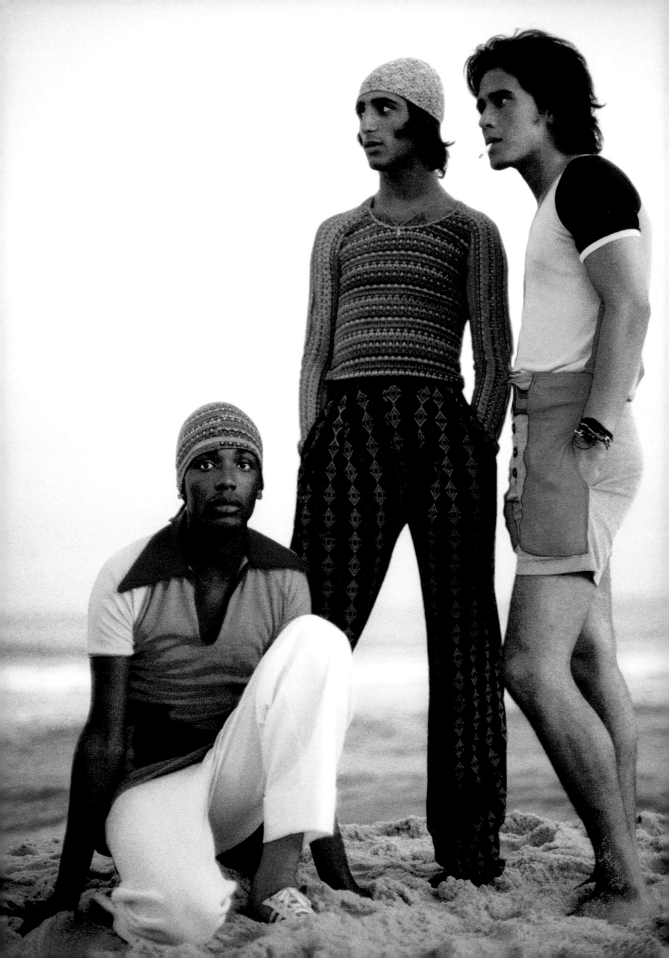

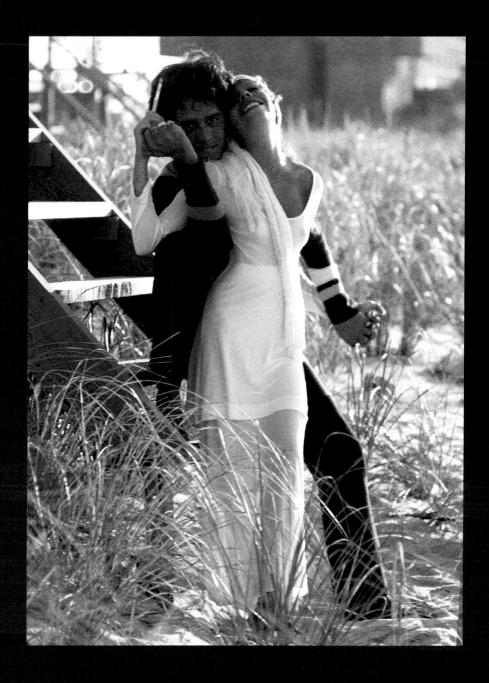

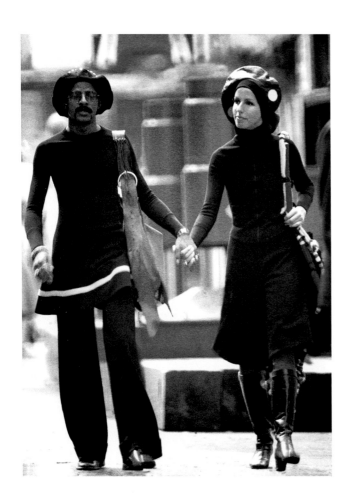

"Stephen Burrows' world is a very special one. It includes the hard chic of black leather studded with nailheads and the youthful exuberance of bright colors that are mixed but never matched."

ANNE-MARIE SCHIRO,
New York Times Magazine, September 20, 1970

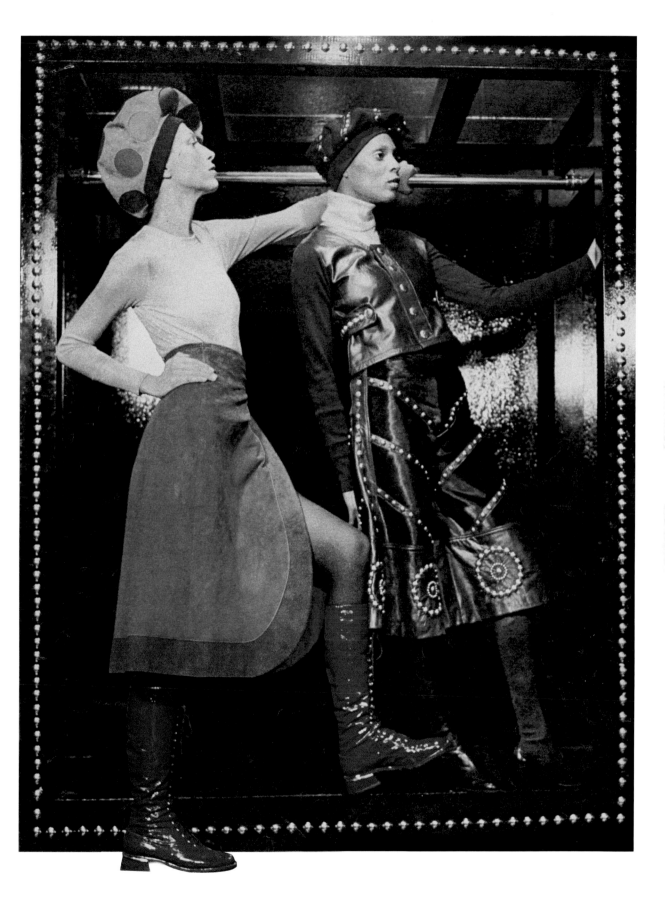

SIL

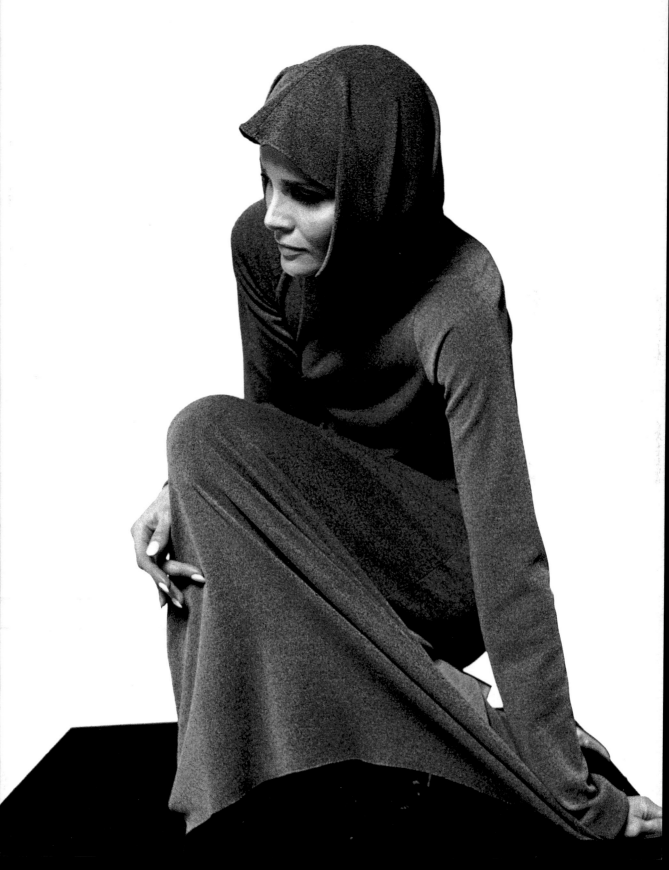

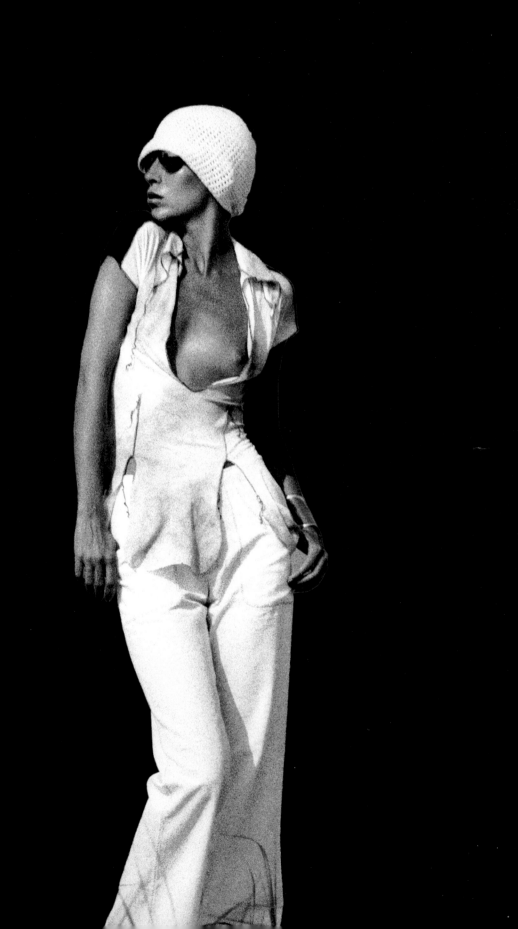

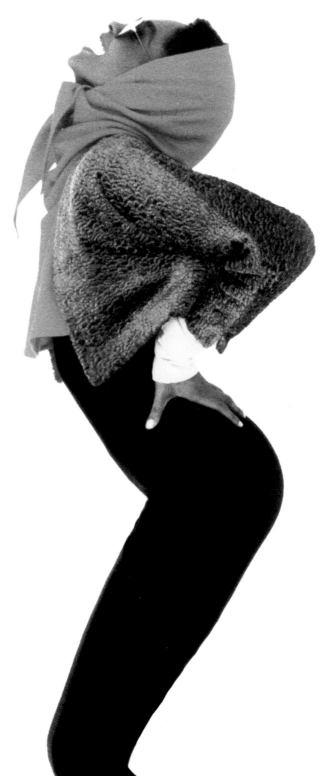

Opposite:
Elsa Peretti, 1971

Above:
Model Roshumba in body-hugging stretch design with textured short jacket, 1989

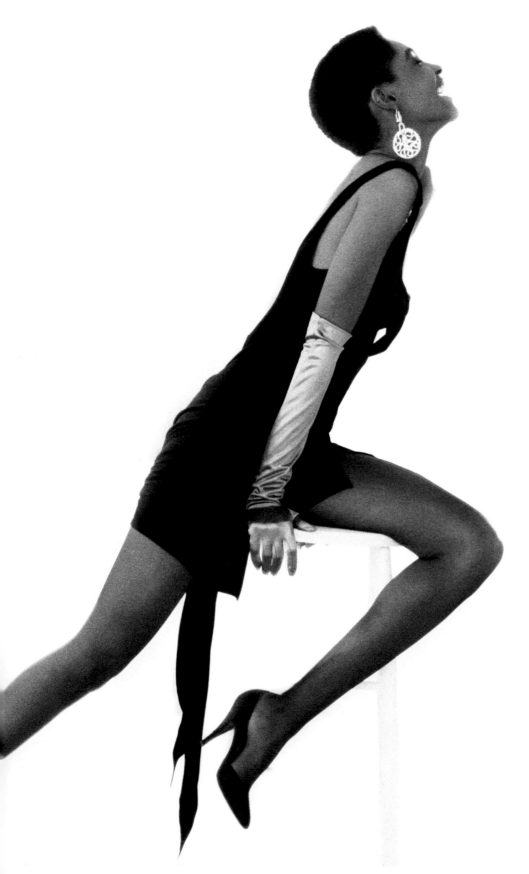

Above:
Roshumba in cocktail
dress with tail, 1983

Opposite:
Deanna Lambert in
matte jersey, 1969

STEPHEN BURROWS

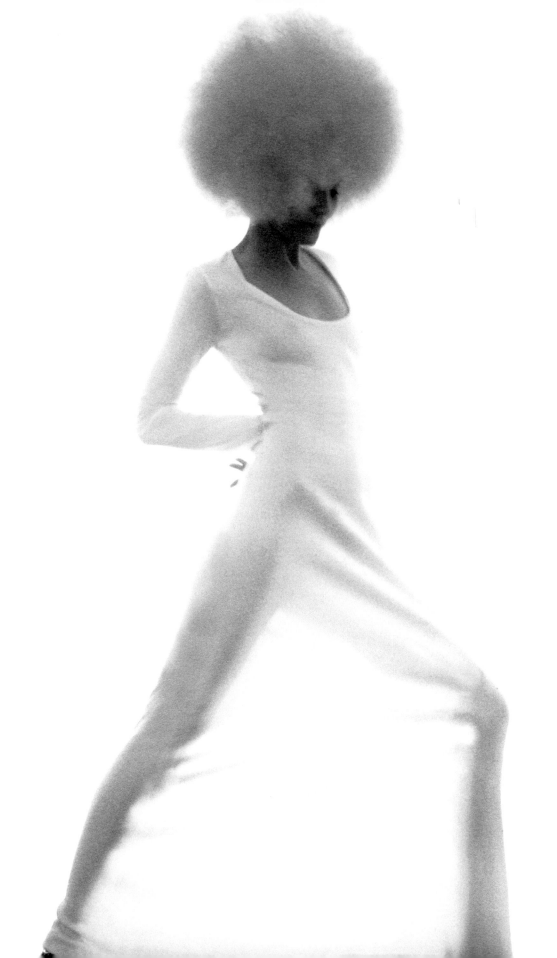

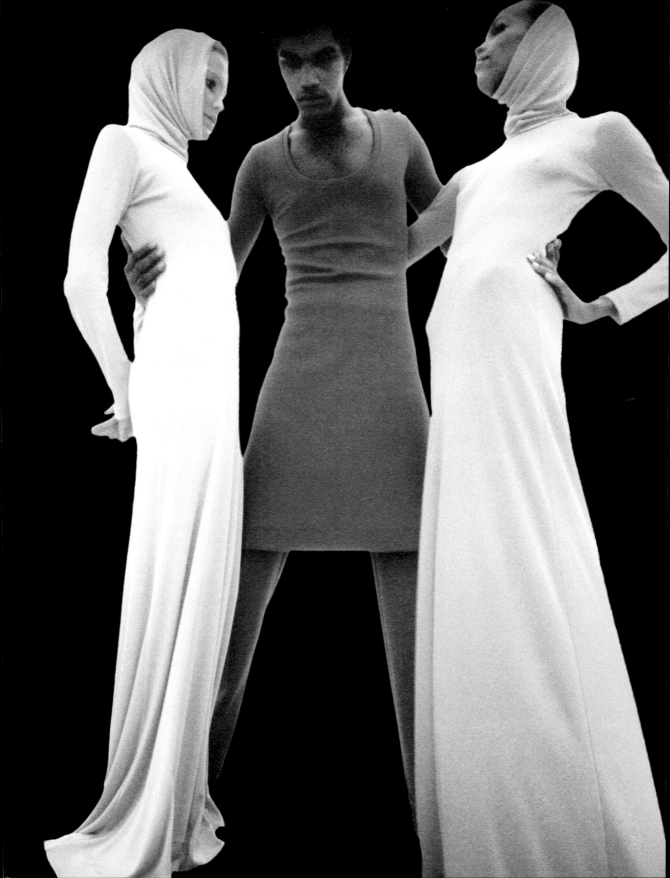

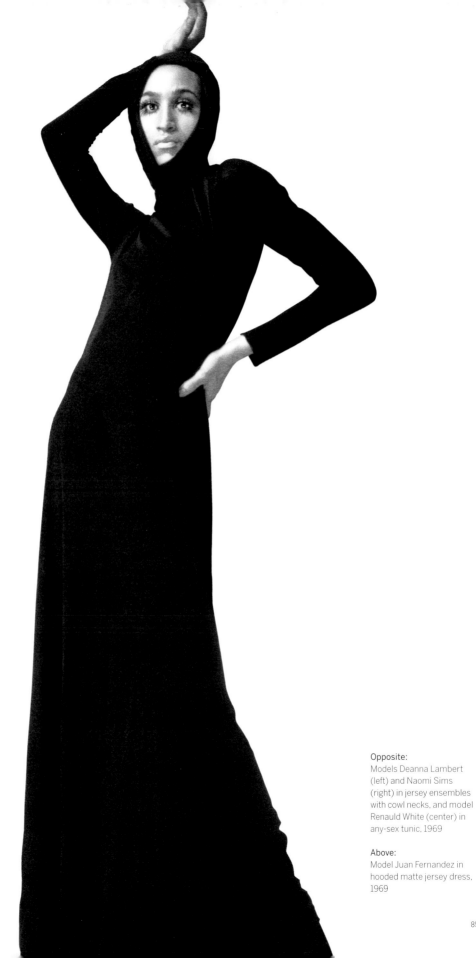

Opposite:
Models Deanna Lambert
(left) and Naomi Sims
(right) in jersey ensembles
with cowl necks, and model
Renauld White (center) in
any-sex tunic, 1969

Above:
Model Juan Fernandez in
hooded matte jersey dress,
1969

"COSMIC

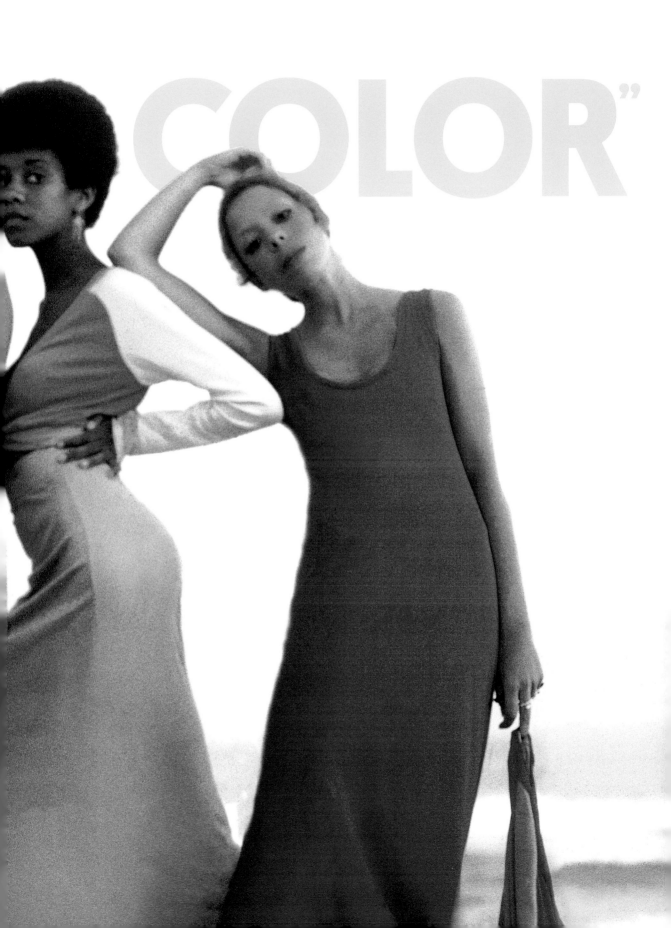

COLOR"

Previous Page:
Matte jersey dresses and
separates, Fire Island, 1969

Opposite:
Stephen Burrows illustration
for Fall 1972 collection with
color palette

Stephen Burrows's maverick approach toward color has been his calling card since early in his career. Summoning the full spectrum as his palette, Burrows's clothes envelop the human form in a slinky rainbow. Fauvist in its defiant color field juxtapositions, his design aesthetic consistently rejects the complacency of tamer muted schemes. With skillful manipulation, Burrows creates unlikely color creations, uniting strong reds with chrome yellows, pungent magentas, acid greens... As he told *Vogue*'s Own Boutique in 1971, Burrows embraced "Spacey looks . . . You know, that look of being in outer space . . . cosmic colors . . . that electric blue, that electric purple."

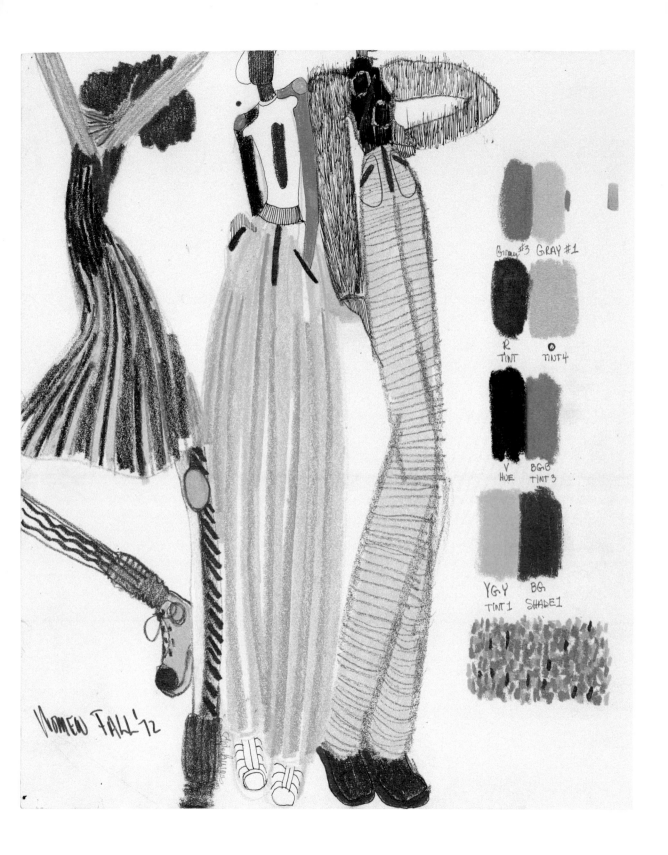

WOMEN FALL '12

Gray #3 GRAY #1

R Ø
TINT TINT4

V BG·B
HUE TINT 3

YG·Y BG
TINT 1 SHADE1

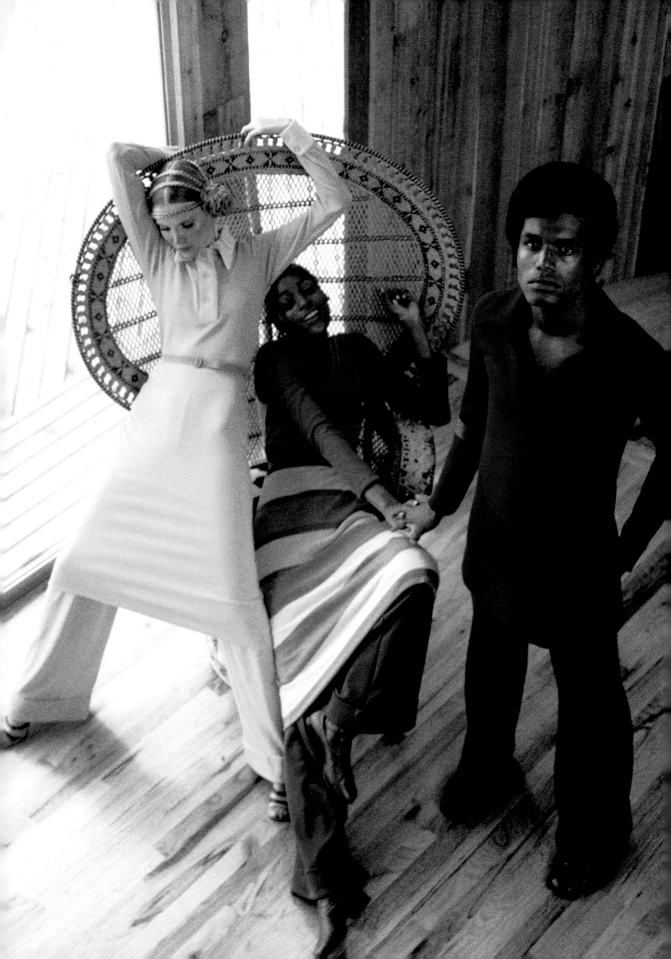

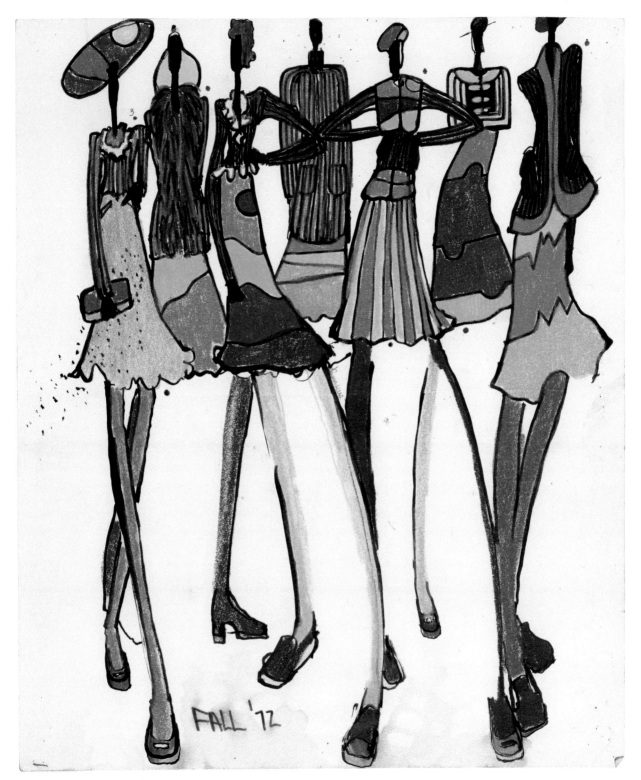

FALL '72

Opposite:
Any-sex jersey tunics,
1969

Above:
Illustration by Stephen
Burrows for Fall 1972

"Though he sticks to the same simple shapes, the color combinations are always different, which makes them completely one of a kind."

New York Post, 1970

Opposite (top left):
A commune member in a colorful look, Fire Island, 1969

Opposite (top right):
Model Lisette Gagné in color block knit cardigan, 1969

Opposite (bottom):
Models in vivid color-block tops and pants, 1969

Following Page:
Models, including Cheryl Tiegs and Jerry Hall (second and third from left), in jersey color-block dresses and separates in *Harper's Bazaar*, 1974

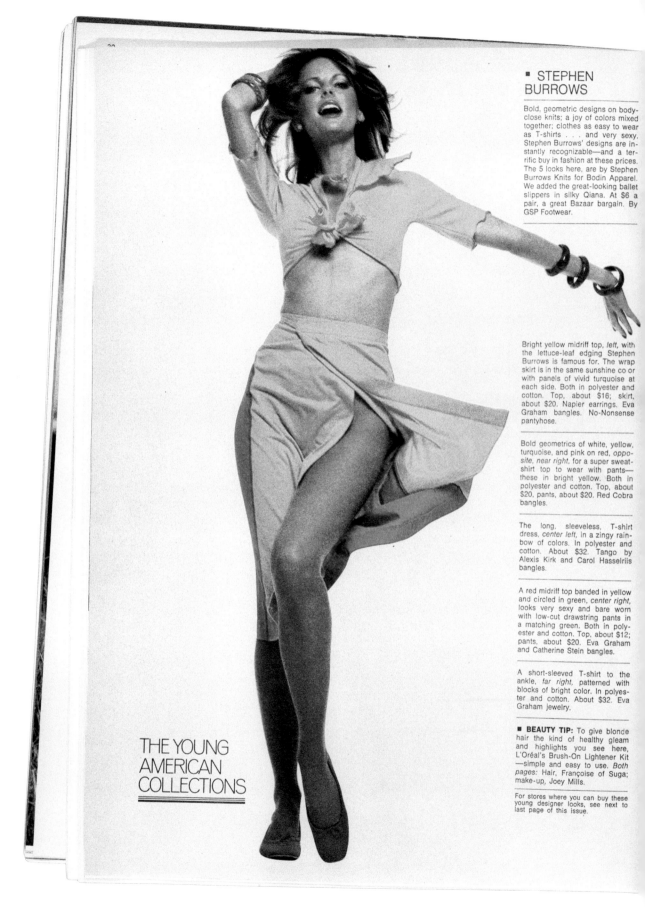

Bold, geometric designs on body-close knits; a joy of colors mixed together; clothes as easy to wear as T-shirts . . . and very sexy. Stephen Burrows' designs are instantly recognizable—and a terrific buy in fashion at these prices. The 5 looks here, are by Stephen Burrows Knits for Bodin Apparel. We added the great-looking ballet slippers in silky Qiana. At $6 a pair, a great Bazaar bargain. By GSP Footwear.

Bright yellow midriff top, *left*, with the lettuce-leaf edging Stephen Burrows is famous for. The wrap skirt is in the same sunshine co or with panels of vivid turquoise at each side. Both in polyester and cotton. Top, about $16; skirt, about $20. Napier earrings. Eva Graham bangles. No-Nonsense pantyhose.

Bold geometrics of white, yellow, turquoise, and pink on red, *opposite, near right,* for a super sweatshirt top to wear with pants—these in bright yellow. Both in polyester and cotton. Top, about $20, pants, about $20. Red Cobra bangles.

The long, sleeveless, T-shirt dress, *center left,* in a zingy rainbow of colors. In polyester and cotton. About $32. Tango by Alexis Kirk and Carol Hasselriis bangles.

A red midriff top banded in yellow and circled in green, *center right,* looks very sexy and bare worn with low-cut drawstring pants in a matching green. Both in polyester and cotton. Top, about $12; pants, about $20. Eva Graham and Catherine Stein bangles.

A short-sleeved T-shirt to the ankle, *far right,* patterned with blocks of bright color. In polyester and cotton. About $32. Eva Graham jewelry.

■ **BEAUTY TIP:** To give blonde hair the kind of healthy gleam and highlights you see here, L'Oréal's Brush-On Lightener Kit —simple and easy to use. *Both pages:* Hair, Françoise of Suga; make-up, Joey Mills.

For stores where you can buy these young designer looks, see next to last page of this issue.

THE YOUNG
AMERICAN
COLLECTIONS

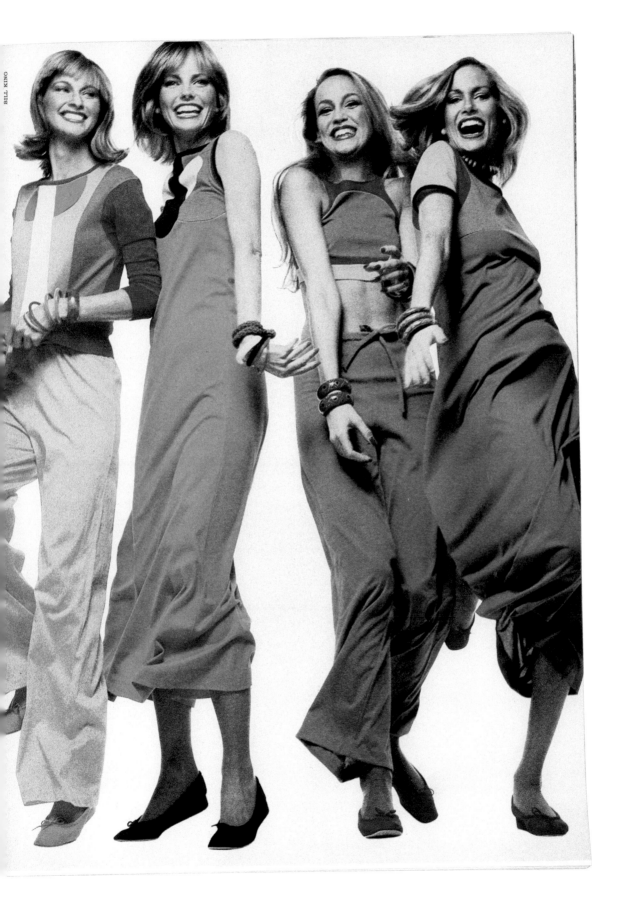

#5027
lips

#5028
2pc pajama

"SAVAGE"
PRINTS

Previous Page:
Illustration by Stephen Burrows for two-piece pajamas, 1973

Opposite:
Model Iman in sand-dune-printed rayon crepe top and matte jersey skirt, 1977

In addition to his strong blocks of solid color, Stephen Burrows has always worked in printed fabrics, many of which are of his own design. His preference stems from their play of broken color and the way that it dances across a surface. Many of his favorite patterns are stylized and thematic, including birds in flight and marine motifs. Burrows's signature "bubble" prints derive from his nickname, which refers to his effervescent laughter and inspired him to experiment with the effects of iridescence and methods of depicting transparencies with overlapping color.

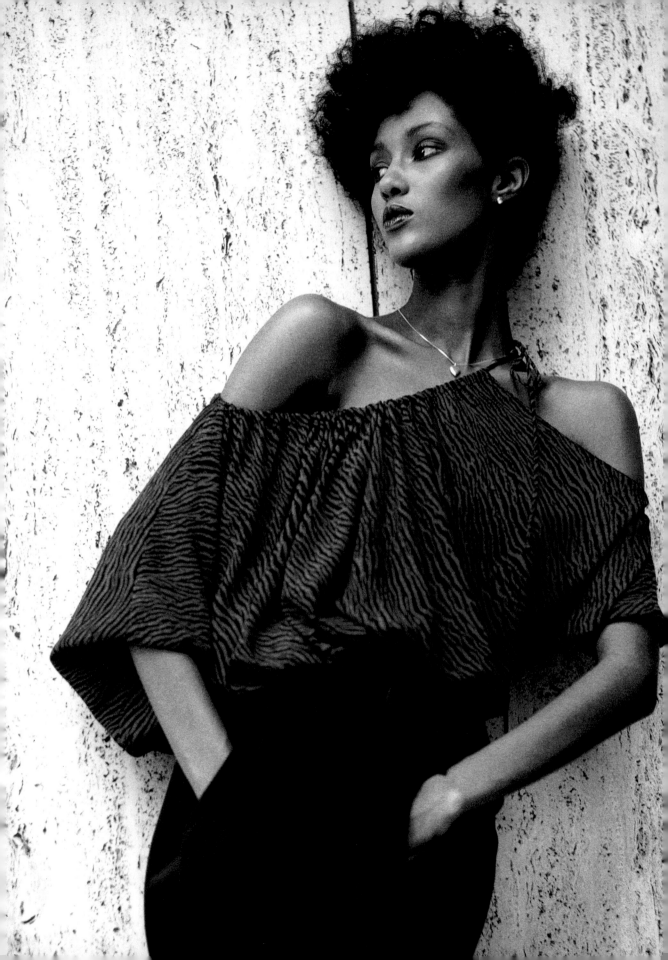

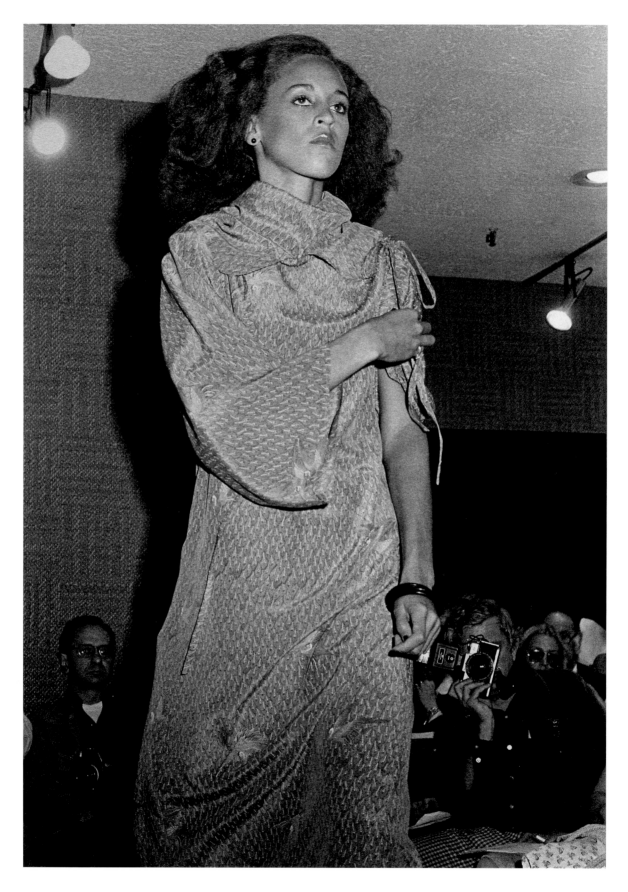

STEPHEN BURROWS

Opposite:
Alva Chinn walks the
runway in a silk dress
printed with cranes
on a field of feathers,
ca. 1978

Right:
Illustration by Stephen
Burrows, stripe and
floral prints on cotton
jersey, 1971

"Savagery is not dead, not as long as Stephen Burrows is around. Now he's added stripes and prints, and when he gets them all going together, you just don't know where to look first."

Women's Wear Daily, May 13, 1971

Above:
Illustrations by Anna Marie Magagna of floral-print cotton jersey dresses for Stephen Burrows' World at Henri Bendel, 1971

Opposite:
Pat Cleveland in tie-dyed silk bi-color wrap top, 1971

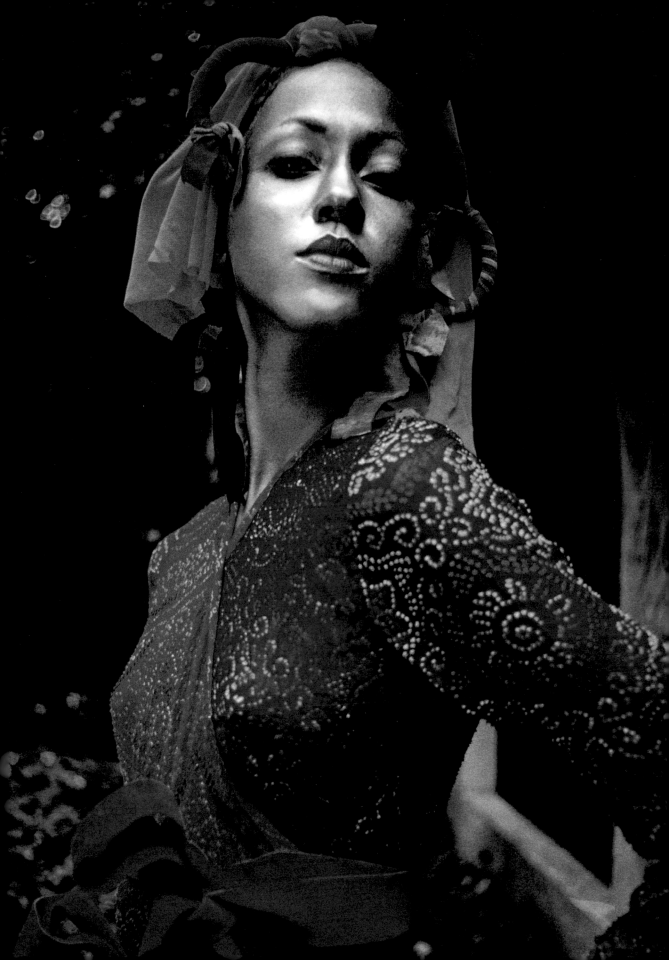

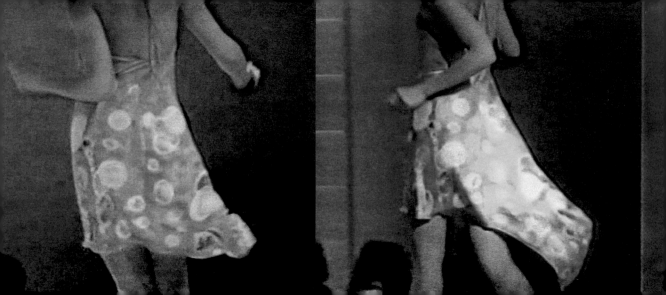

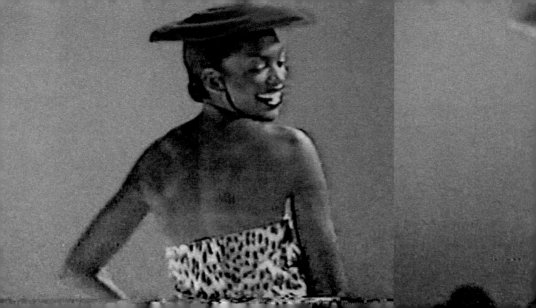

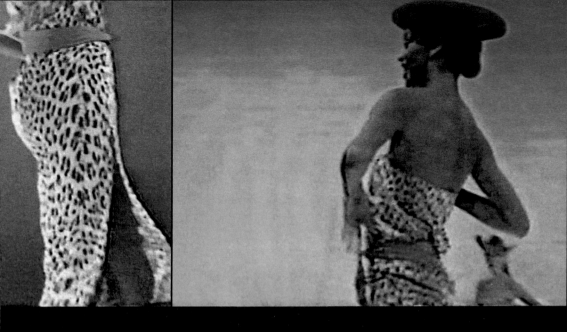

Following Page:
(Back, from left) Lisa Taylor,
Fred Souza, and Bethann
Hardison; (front) Diane Strafaci
and Stephen Burrows in leopard
print rayon for *Interview*
magazine, December 1975

"Bicentennial barbecue" by Richard Sh

Lisa Taylor, Fred Souza, Beth-Ann Hardison and

116

Stephen Burrows Leopardskin Collection for Summer '76. Hair by Joseph Strafacci for Le Tierce. Make-up by Angelo Colon. Photo by Richard Schaefer.

afacci at Stephen Burrows Bicentennial Barbecue.
................ Everyone's wearing Stephen B.

117

SIGNA

TURES

Previous Page:
Actress Barbara Carrera
(left) and model Karen
Bjornson in matte jersey
color-block "train" dresses,
1973

Opposite:
Stephen Burrows's
illustration of lettuce-edge
dresses for Coty fashion
show, 1973

During his formative years as a designer, Stephen Burrows experimented with the distinctive fabrics and innovative techniques that would become his design signatures. The creative formula behind his late 1960s preliminary "commune" period—patchwork jerseys, skintight leathers, and garments that could be worn by "any sex"—crystallized into the sinuous, body-conscious styles devoured by the bone-thin devotees of Stephen Burrows' World at Henri Bendel. Innovations that evolved into his design hallmarks included distinctive lines of bloodred zigzag topstitching, a rejection of structural interiors and linings, the use of metallic chain-mail fabrics, and, most iconically, his frenetic "lettuce" edging.

Originally a workroom stitching mishap, Burrows's first "lettuce" edge was the outcome of an inadvertent overstretching and stitching of a featherweight jersey hem, which produced an undulating, wavy edge. Tickled by the result, Burrows explored it further, stretching the fabric even more and stitching with a zigzag machine. He named the effect in response to a request by *Vogue* editor Diana Vreeland, who had envisioned a dress in "lettuce green" for a shoot she was planning in Bali. His so-named "lettuce edge" reminded him of frizzy lettuce, and Burrows used it to finish his dress for the assignment. Lettuce edges have become an essential element of his designs, perpetually in motion and consistent with the lightness and lighthearted spirit of his garments.

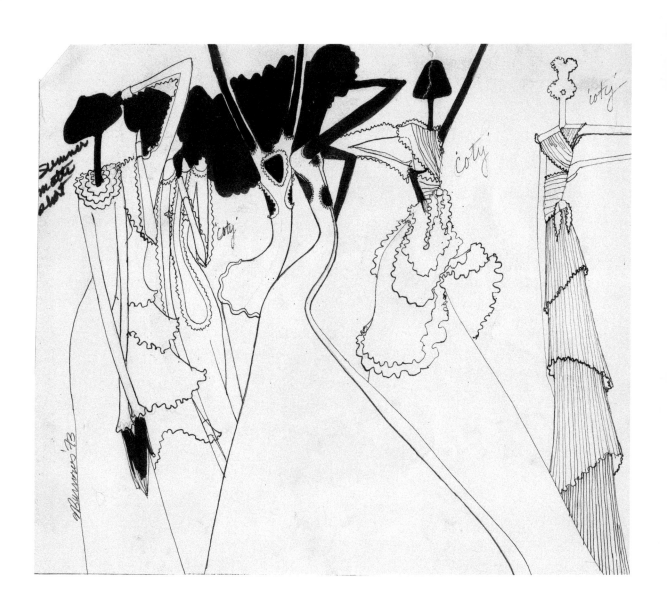

"Though plenty of designers have borrowed the lettuce leaf for their clothes, it was actually invented by Stephen several years ago. It's one of the freshest, most feminine tricks anybody has thought of in a long time."

EUGENIA SHEPPARD,
New York Post Magazine, June 16, 1972

Lauren Hutton in two-piece black matte jersey dress with lettuce-edge finishing. Photograph by Richard Avedon for *Vogue*, October 1973

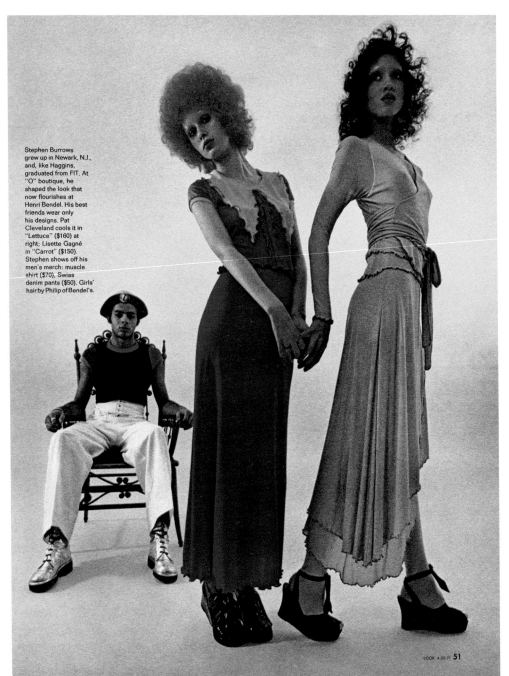

Stephen Burrows
grew up in Newark, N.J.,
and, like Haggins,
graduated from FIT. At
"O" boutique, he
shaped the look that
now flourishes at
Henri Bendel. His best
friends wear only
his designs. Pat
Cleveland cools it in
"Lettuce" ($160) at
right; Lisette Gagné
in "Carrot" ($150).
Stephen shows off his
men's merch: muscle
shirt ($70), Swiss
denim pants ($50). Girls'
hair by Philip of Bendel's.

LOOK 4-20-71 **51**

Left:
Lisette Gagné (left) and Pat
Cleveland in matte jersey
dresses with lettuce-edge
finishing, *LOOK* magazine,
April 1972

Opposite:
The first dress to incorpo-
rate lettuce-edge finishing:
Norma Jean Darden in
two-piece wrap dress in
turquoise matte jersey for
Stephen Burrows' World at
Henri Bendel, 1972

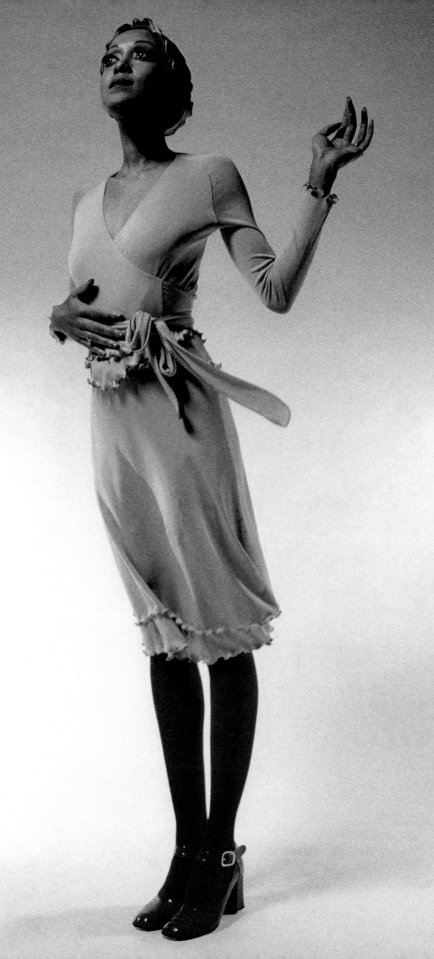

"When he draped clothes on my body, I felt like I was being reborn, like being reincarnated as a butterfly."

PAT CLEVELAND
FQ Magazine, Spring 2005

Pat Cleveland in Burrows's ubiquitous chain-mail top and red chiffon skirt in the revolving door at the original Henri Bendel on West 57th Street, 1977

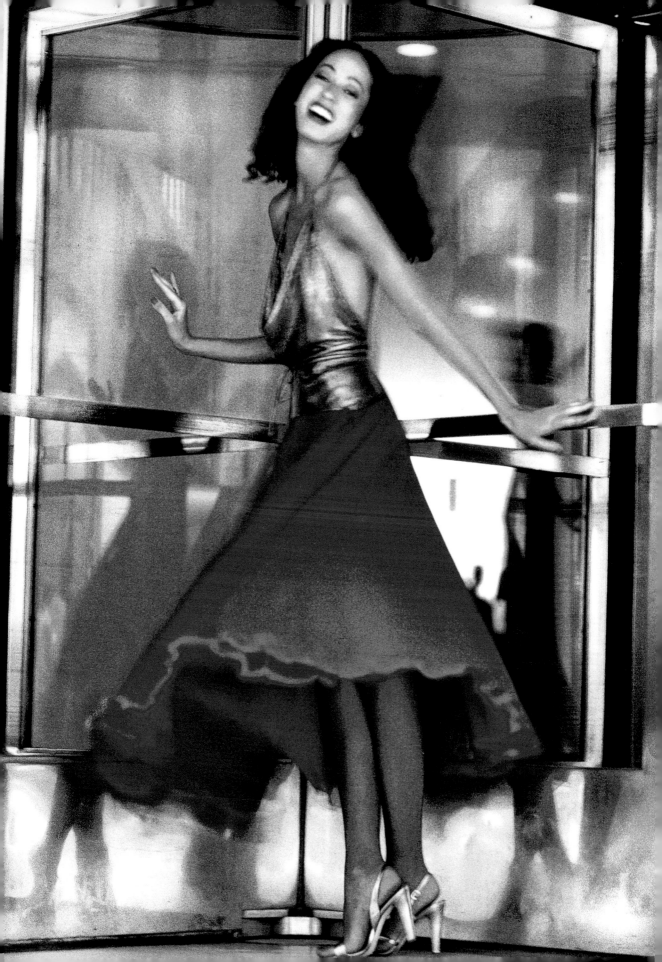

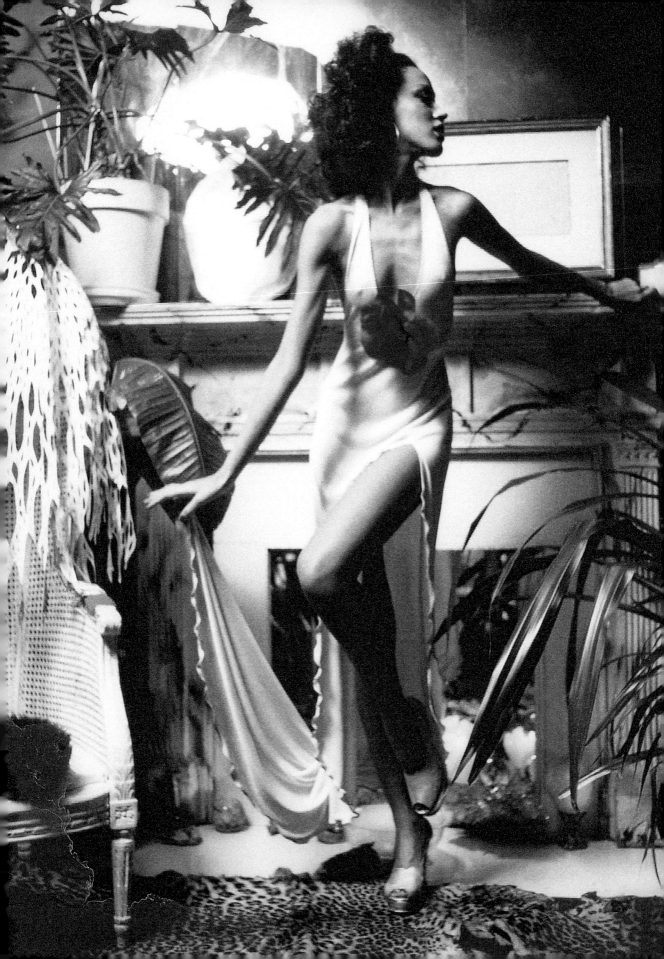

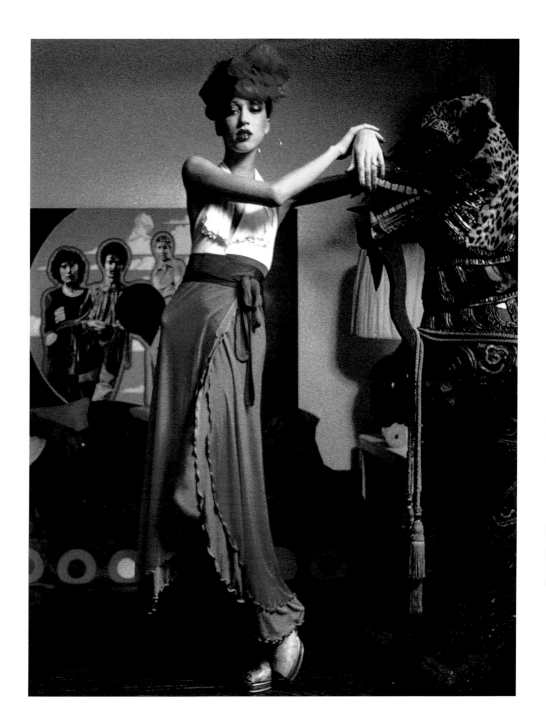

Opposite:
Pat Cleveland in halter-neck evening dress with deep slit and train; white leather cape with hand-tooled cutouts draped at left, 1972

Above:
Pat Cleveland in matte jersey halter dress with double-layered skirt in contrasting colors and top with red top-stitching, 1972

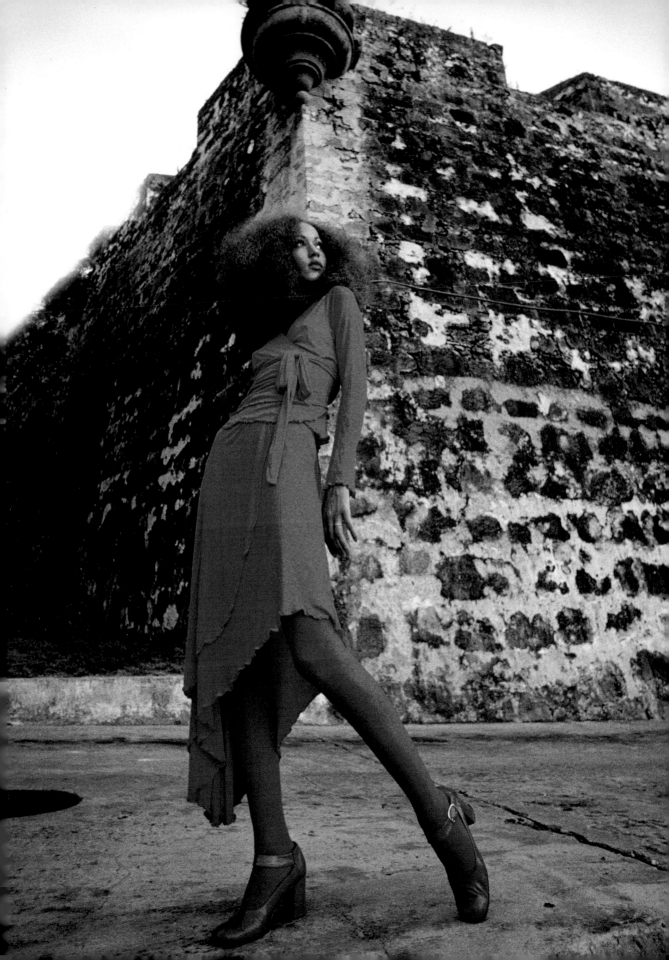

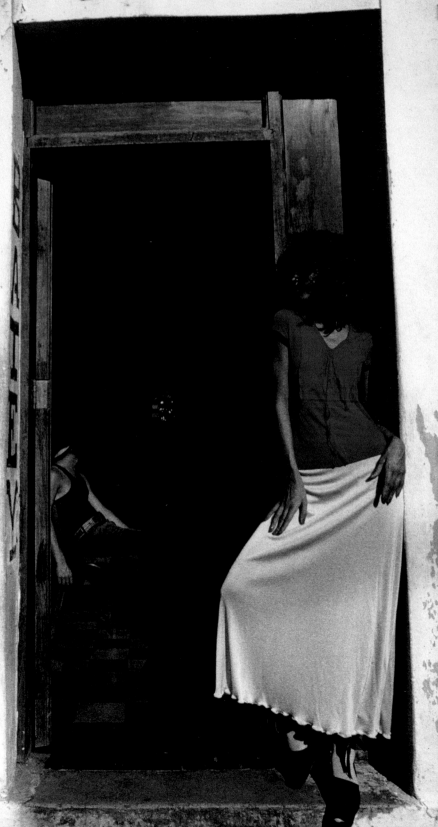

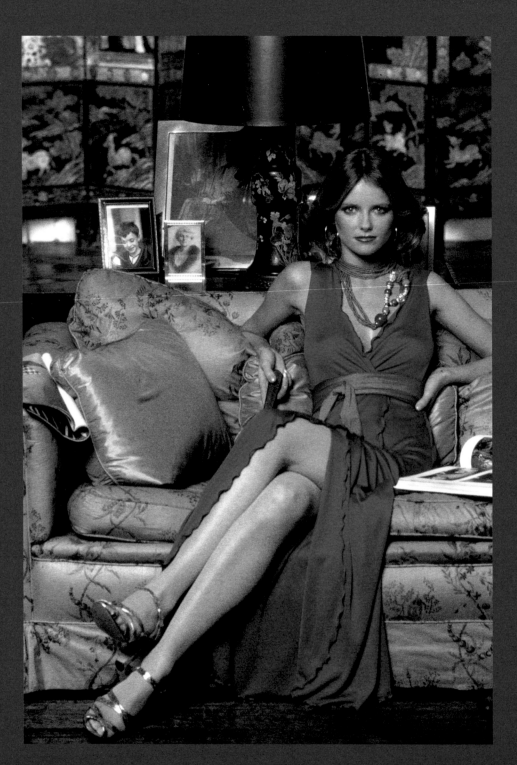

Previous Spread (left):
Pat Cleveland in two-piece
matte jersey with wrap top
(chosen by Diana Vreeland
for *Vogue* shoot in Bali),
in San Juan, Puerto Rico,
1972

Previous Spread (right):
Cleveland in matte jersey
skirt and top with long
pointed collar, San Juan,
Puerto Rico, 1972

Left:
Cheryl Tiegs in wrap eve-
ning dress with signature
finishing, 1973

Opposite:
Model in red matte jersey
wrap evening gown with
bell sleeves, October 1974

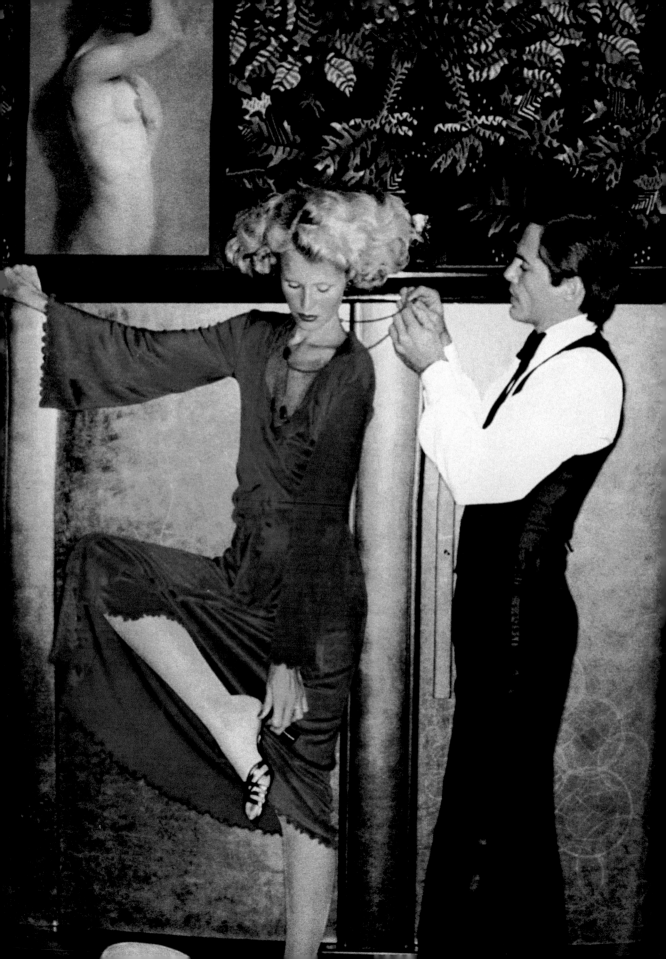

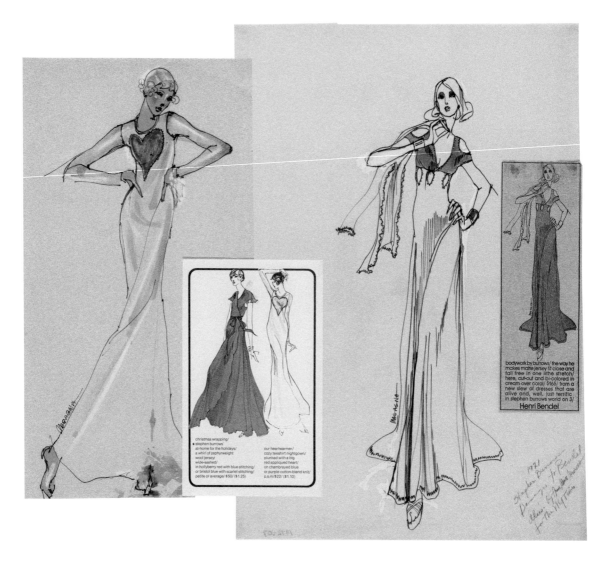

Left:
Illustration by Anna Marie Magagna of evening dress and scarf by Stephen Burrows for Henri Bendel, 1971

Right:
Illustration by Anna Marie Magagna of Burrows jersey dress with lettuce-edge heart, 1972

Opposite:
Janice Dickinson walking the runway in layered chiffon dress, 1978

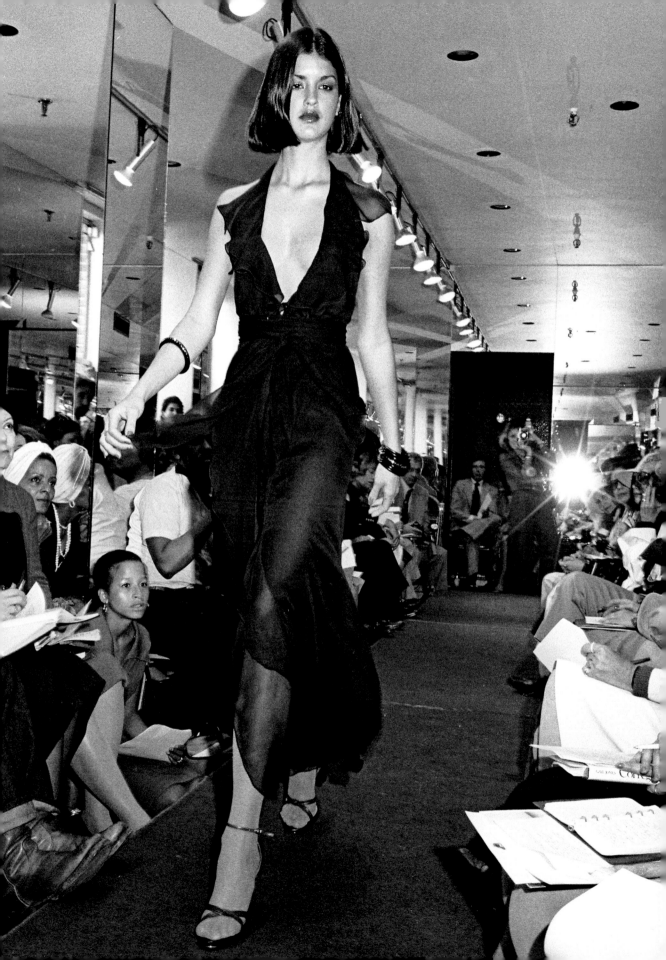

Left:
Elsa Peretti in tie-dyed top with signature zigzag finishing and snap-front cotton pants, Fire Island, 1972

Opposite:
Renauld White in briefs and Alva Chinn in bikini with blood-red zigzag stitching, 1974

STEPHEN BURROWS

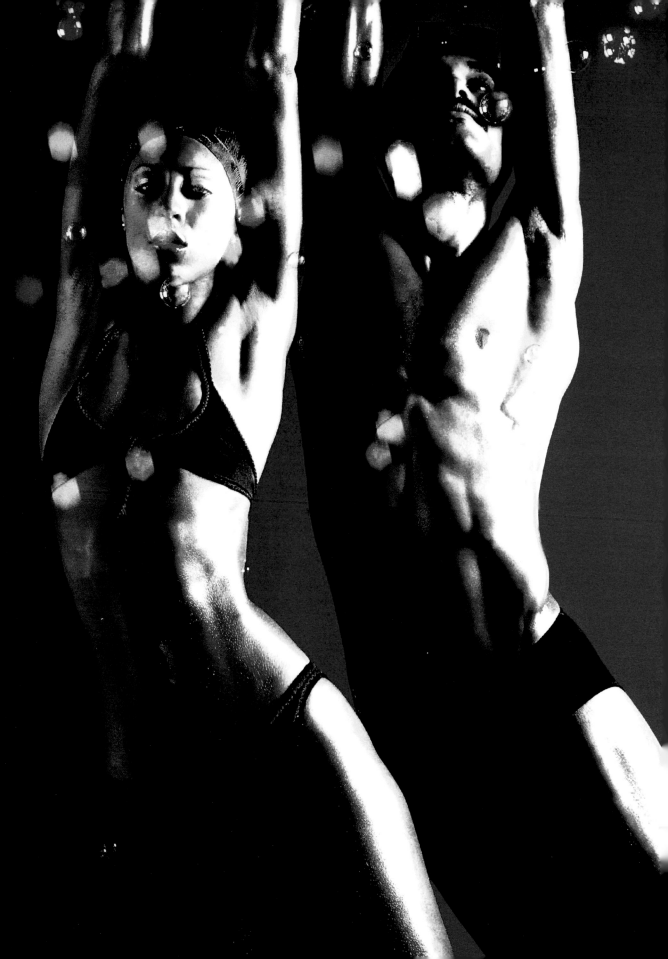

BURROWS ON BURROWS

Adapted from an interview conducted by Daniela Morera
before "The Best Six" fashion event in Tokyo, 1978.

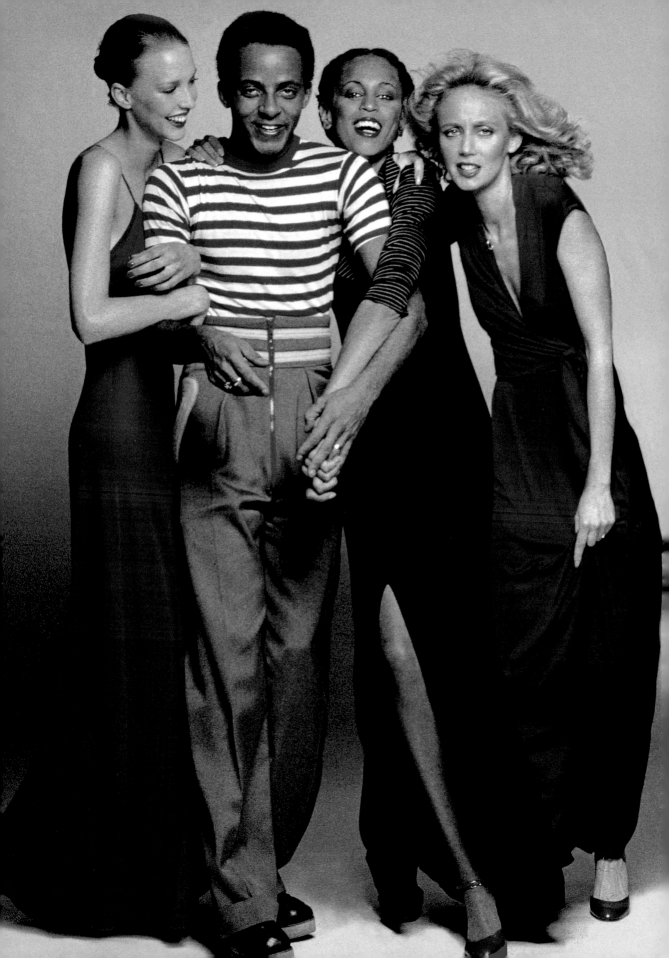

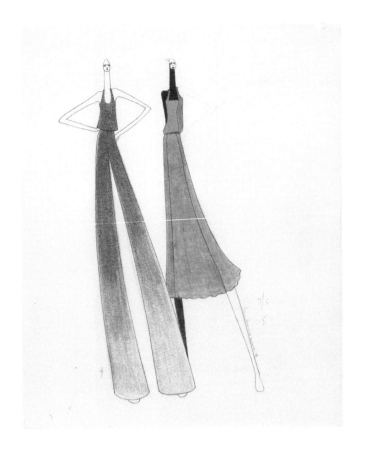

"You can't make fashion by looking through books. You've got to move on, go forward, keep moving!"

"Red is my favorite color—the color of blood, the color of life. The stitching on my clothes is always and only red."

"Every piece is for a superhero or a superheroine. Everyone wants to look like a superperson, not like someone from 1940."

"New York is color, music, food. New York is the world's heart. I cannot go away for longer than four days without suffering. New York is me, and I am New York. New York is a fantastic mixture; it's like an orgasm."

Left:
Stephen Burrows sketch of designs with blouson bodices for his Summer 1974 collection

Opposite:
Burrows measuring toile in his studio, ca. 1978

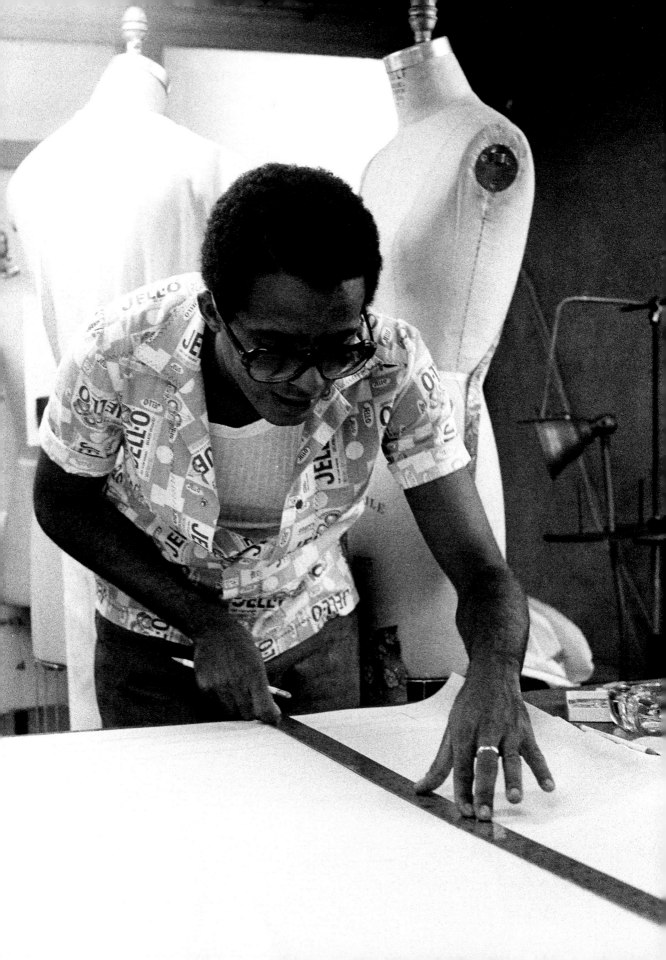

"My magic moment is midnight—it's like living 48 hours in a few seconds."

"We have to keep on changing. I change the décor of my room every few months—right now it's red and white, with colorful feathers falling from the ceiling, gigantic pictures of beautiful people, candlelight . . . and leopard skin, of course."

"In every discotheque I have my favorite corner. I dance there, and I stay [in that spot] all night. The people looking for me know where to find me—I'm in my space."

"I like basic colors— the colors of toys. Clothes should be like toys; clothes are playthings."

Left:
Stephen Burrows's illustration of a print dress designed for Norma Jean Darden, 1971

Opposite:
Draping muslin on a dress form, ca. 1978

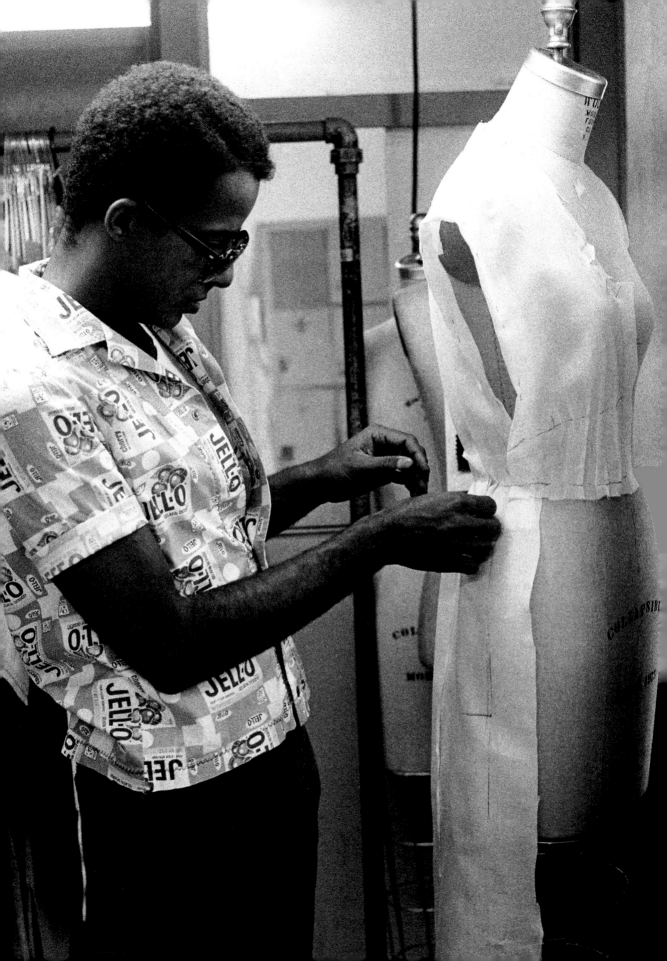

"My artistic medium is fabric, and I like the way jersey moves and drapes—it's flexible. That's why I love knit, too—it's not rigid."

"I believe in destiny, hope, polygamy, charity, and universal communications."

Left:
Illustration for suit and cape by Stephen Burrows, 1974

Right:
Sketch by Burrows of cashmere coat with lynx fur trim, 1971

Opposite:
Sewing in the workroom, ca. 1978

Cashmere
lynx coll
and linoin

"Women from big cities— metropolitan, liberated, and powerful women— understand my clothes."

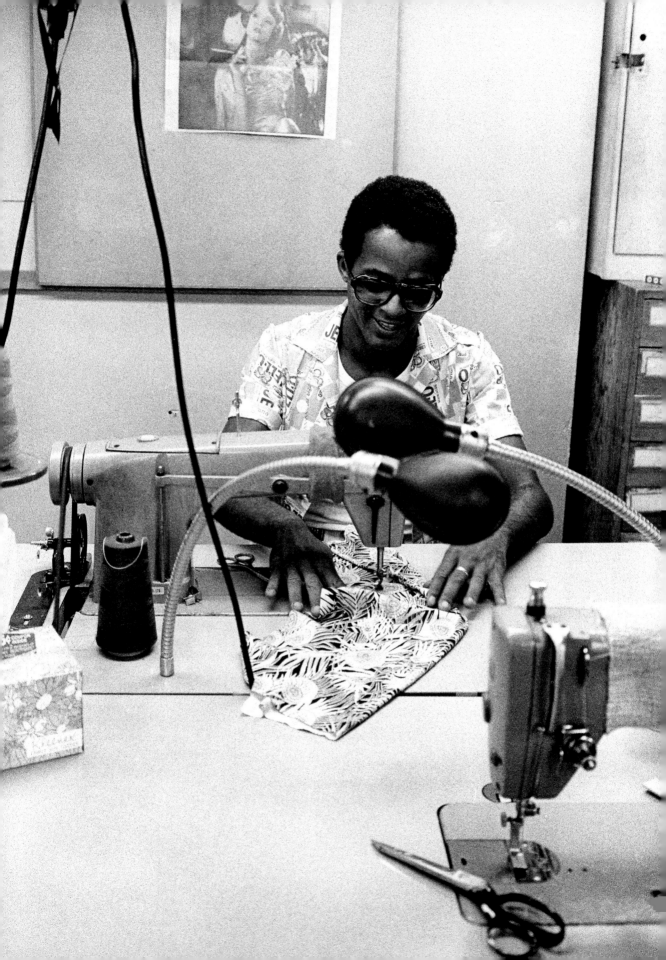

GLAMOU

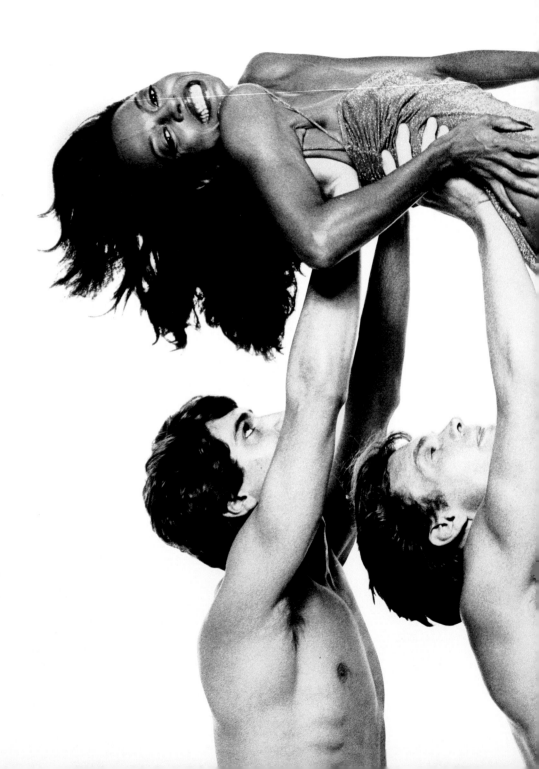

R

"This is the first time I've put on a suit that didn't make me feel like an old lady— you know, like you've gotten to thirty..."

CHER, 1970

The inherent sexiness and flattering sensuality of Stephen Burrows's clothes have accounted for their tremendous celebrity appeal. One of Burrows's earliest *Vogue* editorials (October 1970) featured an early fitting between Cher, then a rising young fashion iconoclast, and the designer at his Stephen Burrows' World boutique at Henri Bendel. This type of editorial validation would set the tone for a slew of pictorial features showcasing such personalities as Bette Midler, Diana Ross, Cicely Tyson, and Barbra Streisand, and culminating with Farrah Fawcett's dazzling gold chain-mail gown she wore as an Oscar presenter in 1978.

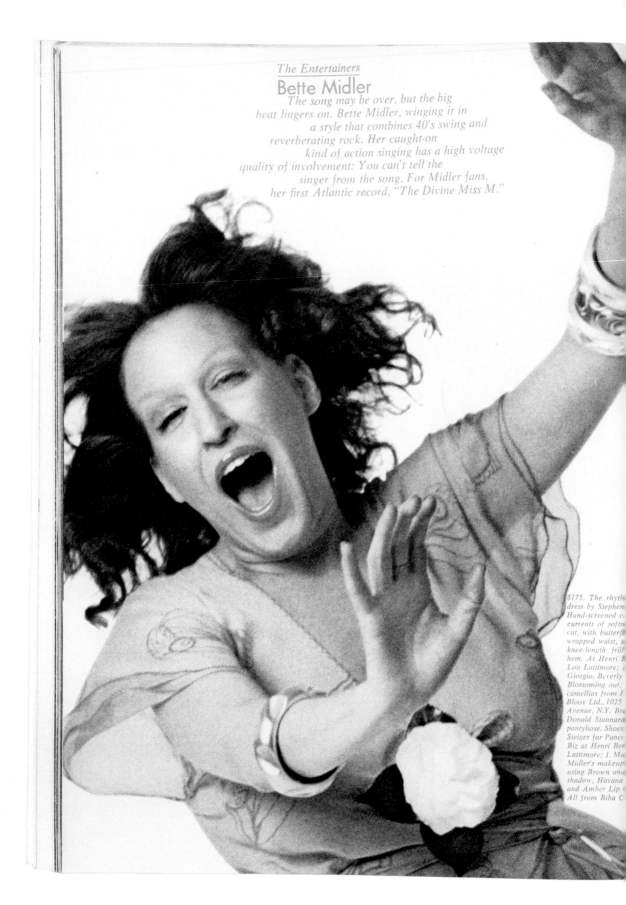

Bette Midler

*The song may be over, but the big
beat lingers on. Bette Midler, winging it in
a style that combines 40's swing and
reverberating rock. Her caught-on
kind of action singing has a high voltage
quality of involvement: You can't tell the
singer from the song. For Midler fans,
her first Atlantic record, "The Divine Miss M."*

$175. The rhyth
dress by Stephen
Hand-screened c
currents of softn
cut, with butterfl
wrapped waist, s
knee-length frill
hem. At Henri E
Lou Lattimore; a
Giorgio, Beverly
Blossoming out,
camellias from J
Bloos Ltd., 1025
Avenue, N.Y. Bra
Donald Stannara
pantyhose. Shoes
Steiger for Panco
Biz at Henri Ber
Lattimore; I. Ma
Midler's makeup
using Brown and
shadow, Havana
and Amber Lip
All from Biba C

142

STEPHEN BURROWS

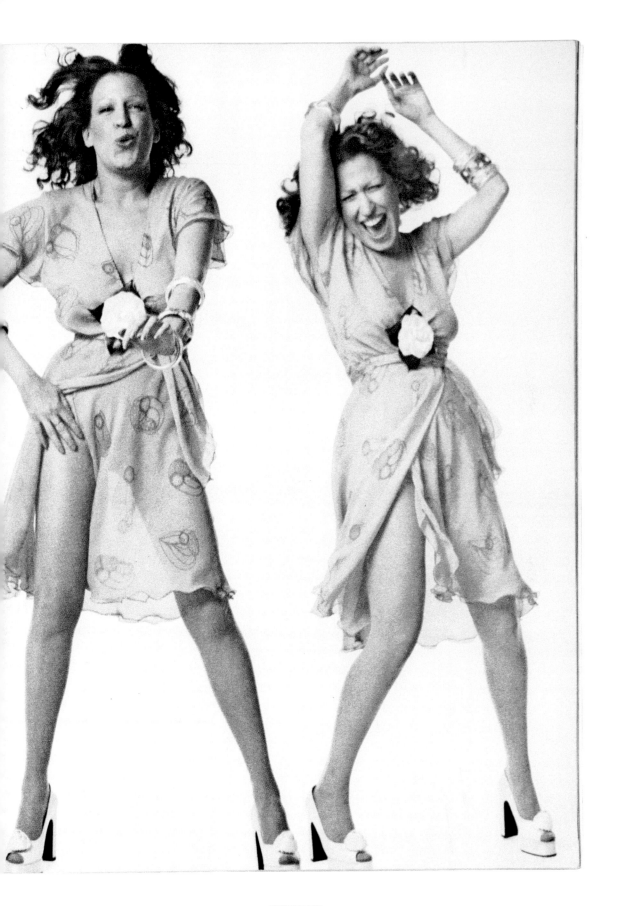

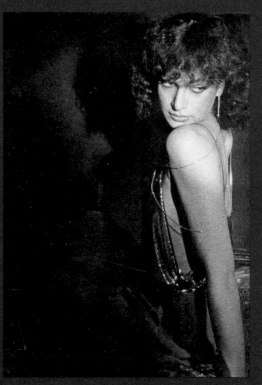

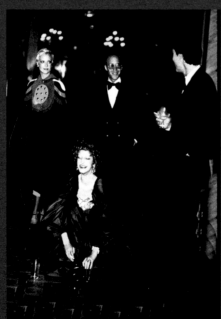

Clockwise from Top Left:
Stephen Burrows with
Marisa Berenson at
Versailles, 1943

Stephen Burrows and Liza
Minelli at Versailles, 1973

Stephen Burrows and Jane
Holzer at Versailles, 1973

Burrows's Fall 1977
collection included pieces
made from Whiting & Davis
metal mesh. Pat Tennant
explained the material to
Women's Wear Daily as
"what your grandmother's
bags were made of."

LouLou de la Falaise
(center) and Halston
(far right) with Stephen
Burrows and Mrs. Norton
Sloan wearing a Burrows
design at Versailles, 1973

Opposite:
Grace Jones in gold-tone
chain-mail top, 1977

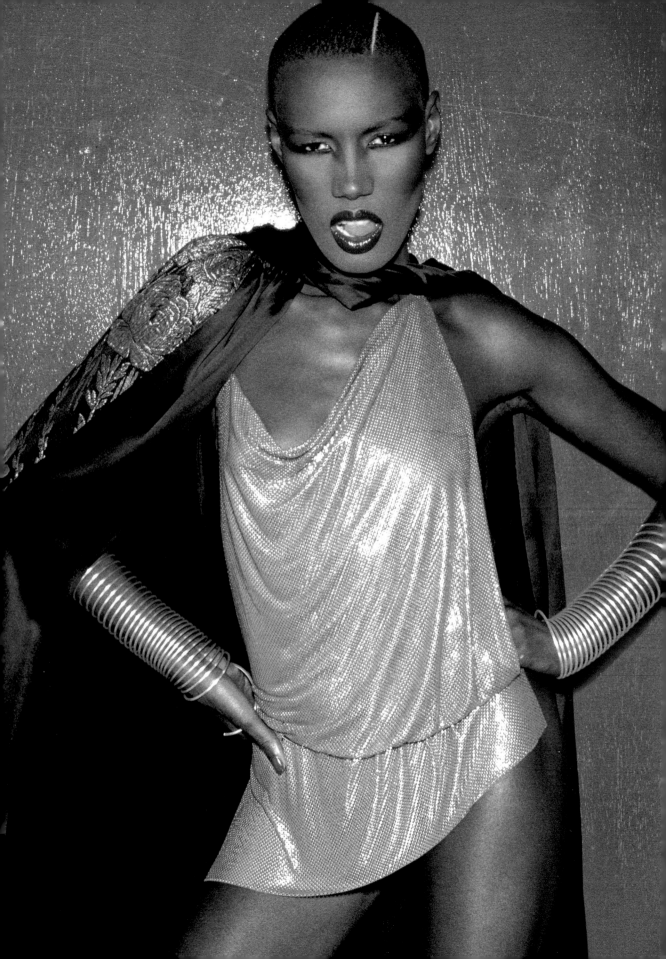

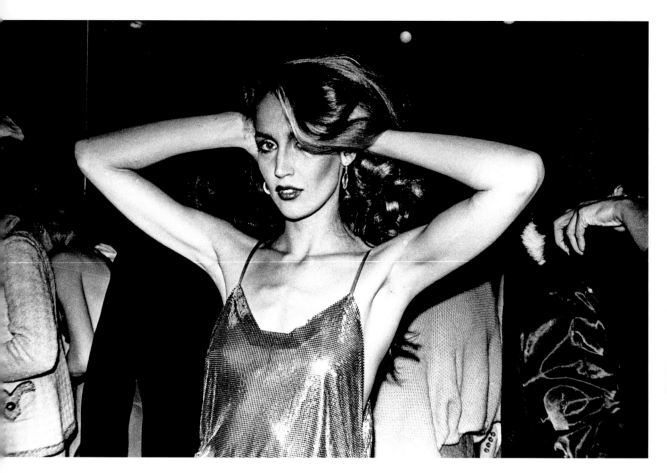

Above:
Jerry Hall in chain-mail top
at Studio 54, 1977

Opposite:
Iman in Whiting & Davis for
Stephen Burrows metal
mesh top, 1977

"He doesn't so much create an outfit as much as he crafts a story through fashion and dares us all to dream, to dance, and to inhabit our bodies."

IMAN

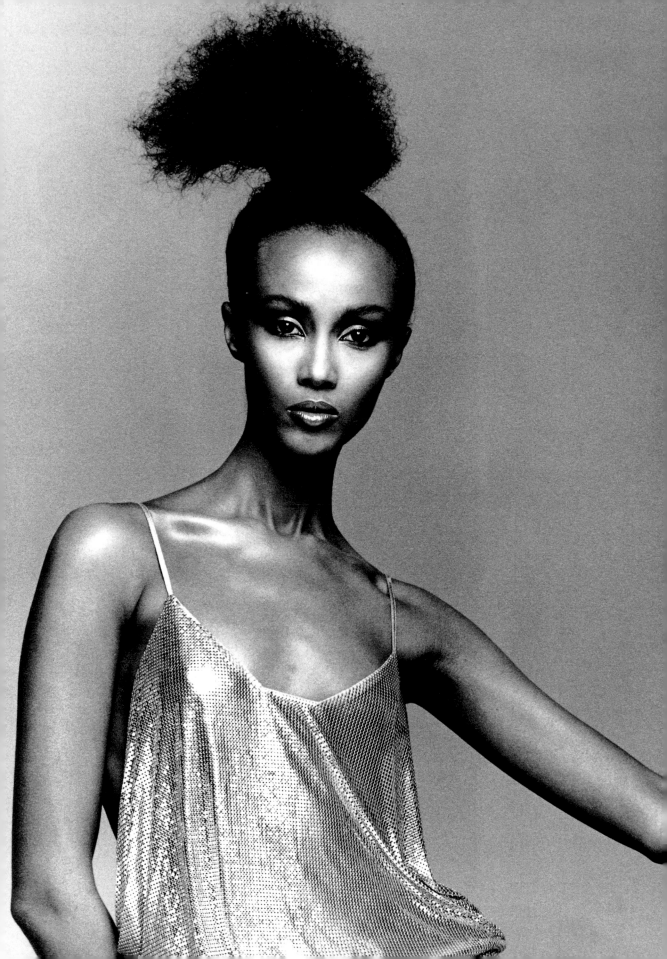

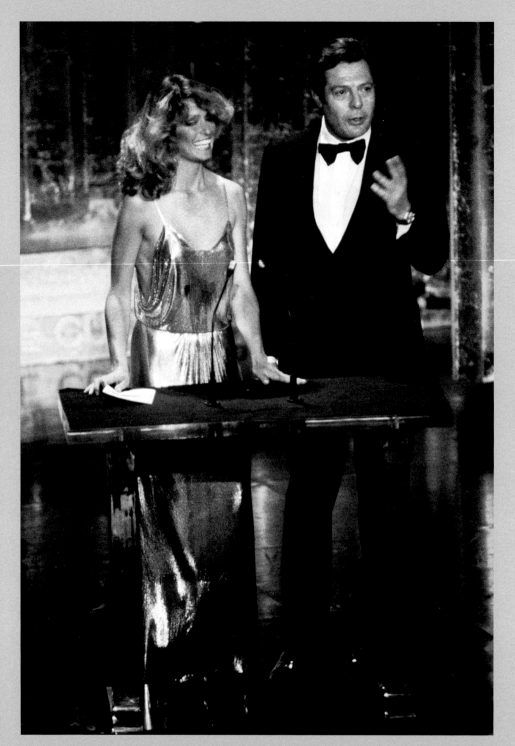

Left:
Farrah Fawcett presenting
the Oscar for Best Film
Editing with Marcello
Mastroianni in Stephen
Burrows's definitive
chain-mail gown, 1978

Opposite:
Farrah Fawcett in Whiting &
Davis for Stephen Burrows
at the Academy Awards,
1978

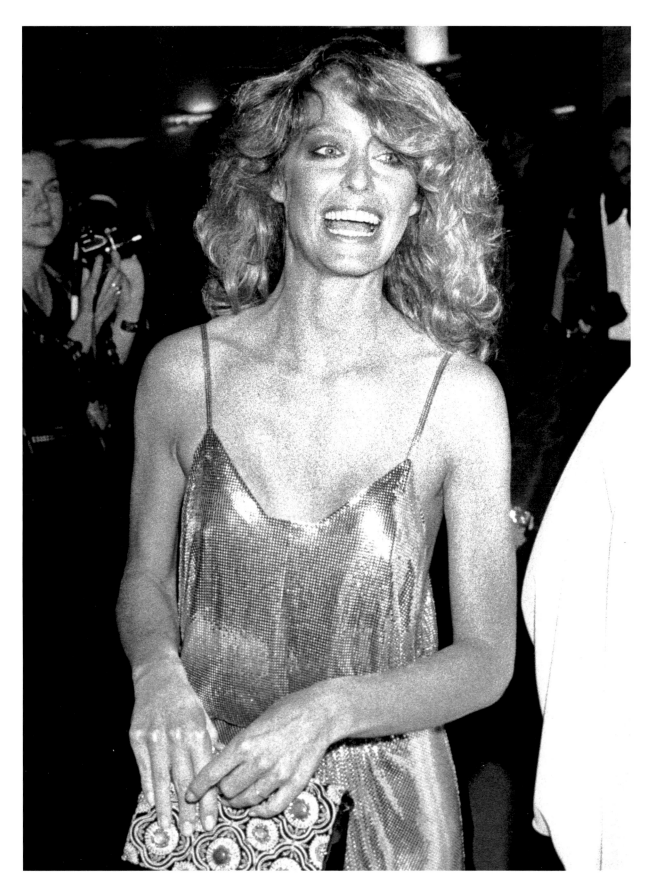

Susan Sarandon Loves Stephen Burrows!

His dresses slide over the body and reveal as much as they cover. He believes in color and mixes bold brights like no one else. The look: strong, sexy, leggy . . . if you have the body—go for Burrows!

...nstructed kimono-
...eeved dress of thinnest
...nerald silk satin . . . a
...rific look for night!
...Stephen Burrows for
...Pat Tennant. About $490.
At Macy's, Herald Square
Stanley Korshak, Chicago
Loretta Blum, Dallas.
**The Burrows way with
color—it sweeps you off
your feet!** Opposite page
...ephen with actress
Susan Sarandon in his
long, fuchsia linen
cardigan jacket, over a
white matte jersey tank
top and rose-coral linen
Bermudas . . . more color
yellow tights and woven
flats that play up legs to
the hilt! By Stephen
Burrows for Pat Tennant.
Jacket, about $200; rayo...
tank top, about 150;
Bermudas, about $130.
At Henri Bendel; Stanley
Korshak, Chicago; Chuc...
Jones & Jack Parker,
Palm Beach, Bal Harbou...
Jane Simon, Birmingham
AL; Sakowitz. **Luxury in
suede,** opposite page,
inset: The deep-sleeved
suede jacket in sapphire
blue with pinked edging
. . . Stephen slips it over
a flower-printed silk halte...
and sapphire silk jodh-
purs, but it's a piece that
could brighten anything!
By Stephen Burrows for
Pat Tennant. Jacket,
about $950; halter, abou...
$200; jodhpurs, about
$280. At Henri Bendel;
John Wanamaker;
Sakowitz. These 2 pages
hair, Louis Alonzo for
Pipino-Buccheri; makeu...
Amy Elfassy. See Fashio...
Guide for details, next to
last page.

Above:
Susan Sarandon in silk charmeuse (left and
carried by Burrows at right) and blue suede jacket
(inset, lower right), *Harper's Bazaar*, February 1981

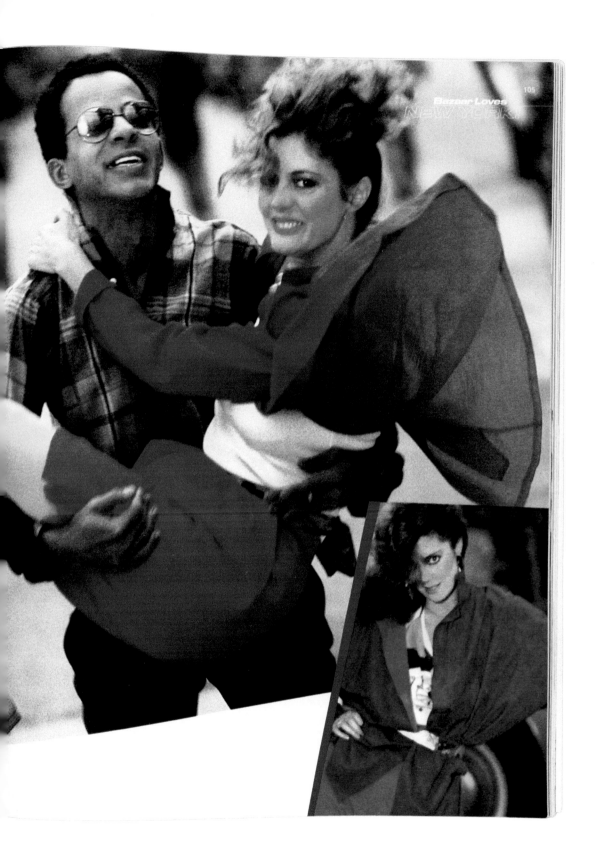

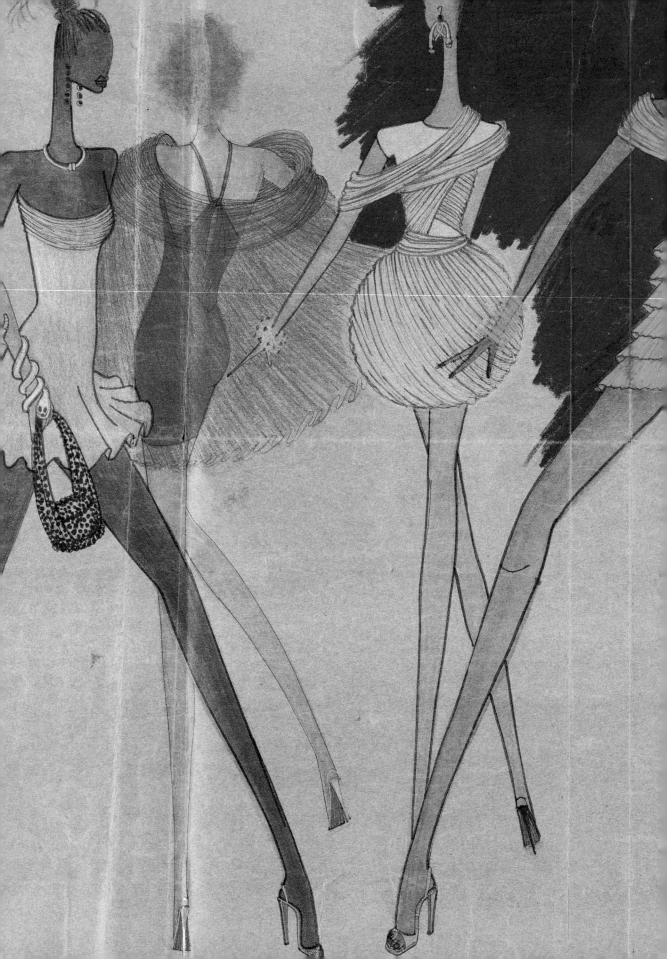

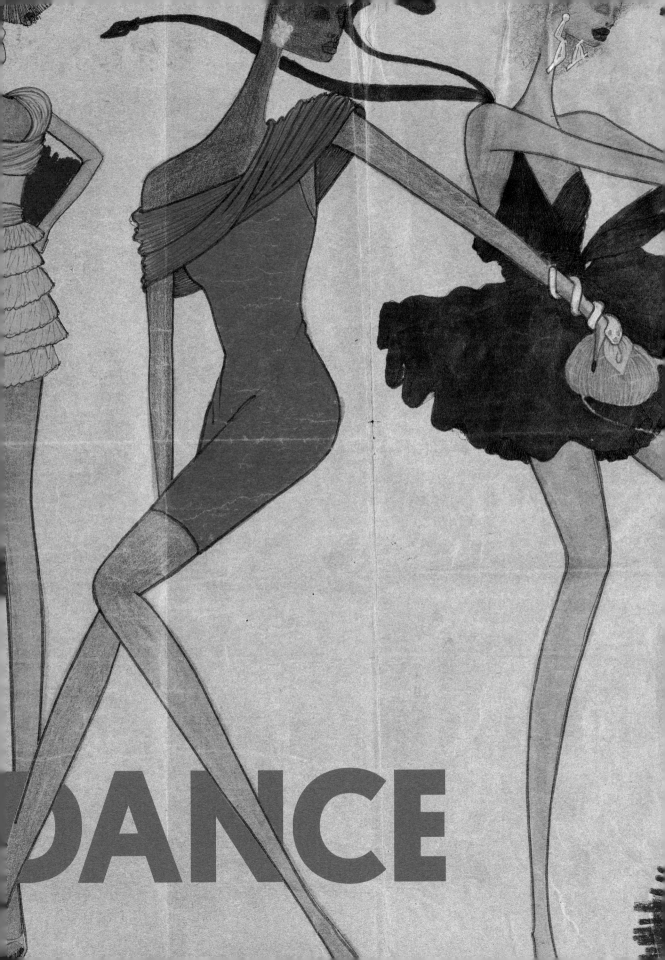

DANCE

Flirty, slinky, seductive—Stephen Burrows's clothes were born to dance. His earliest cuts were "anatomical," caressing the body with soft cotton and wool jersey, studded leather and laced chamois that fit like a second skin. By the early 1970s, his feather jerseys and gossamer chiffons enabled his clothing to function as a second skin, revealing each contour and silhouette.

Key to this effect has been his choice of fabrics. Indeed, throughout his career, Stephen Burrows has optimized the uncomplicated simplicity of his designs through the astute selection of his textiles. From the start of his career, Burrows favored wool and Jasco jersey and bias-silk chiffon. By 1977, he was working in slithering, antique bronze and various-cut colored chain mail to execute gowns and separates that flowed over the body's contours, paralleling the cascading effect of his early leather fringe and feathers. Movers of the late 1970s club scene loved the glittering bugle beads of Burrows's evening garments, which substituted for his earlier edgy metallic studs.

Although Burrows has never designed for stage performance, his clothing has consistently emphasized and enhanced the body in motion. Informed by his passion for rhythmic music and dancing, Burrows's designs have reflected his personal requisites on matters of comfort and mobility. His goal has been to create comfortable clothes for people to wear and enjoy.

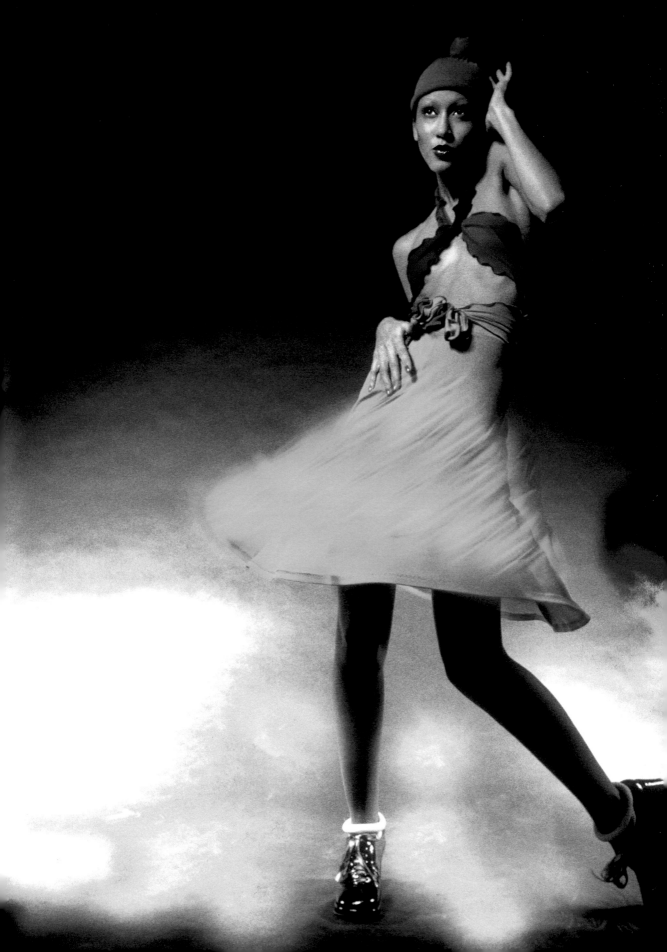

"I can see a girl dancing, and immediately a dress pops into my head. A look. An image. It's just there. Dancing is always in my clothes—the movement; that you can do anything and feel free in the garment."

STEPHEN BURROWS,
The New York Times Magazine, June 5, 1977

Jerry Hall in hand-painted bubble-patterned silk charmeuse tunic and pants, 1978

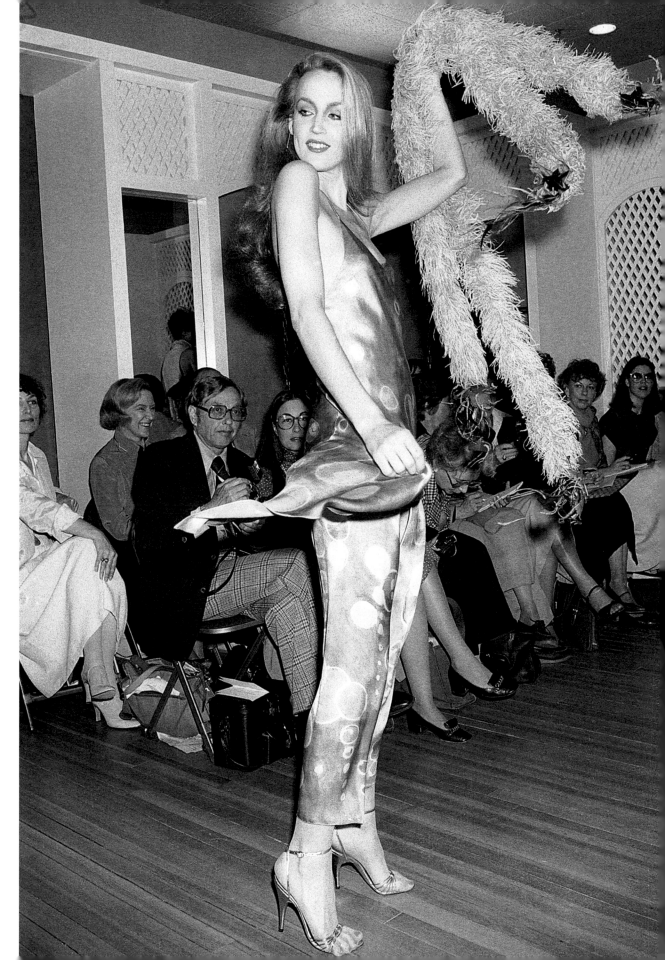

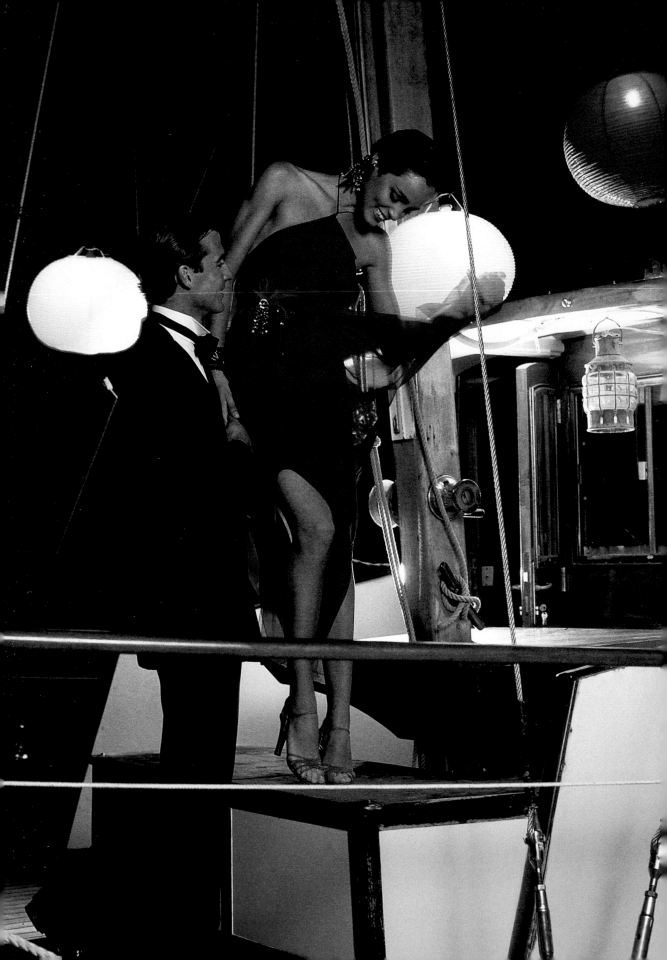

Opposite:
Model Esme in red chiffon halter dress with split skirt, 1978

Right:
Jerry Hall in silk chiffon dress and notch-collared suede vest with pinked finishing, *Harper's Bazaar*, July 1978

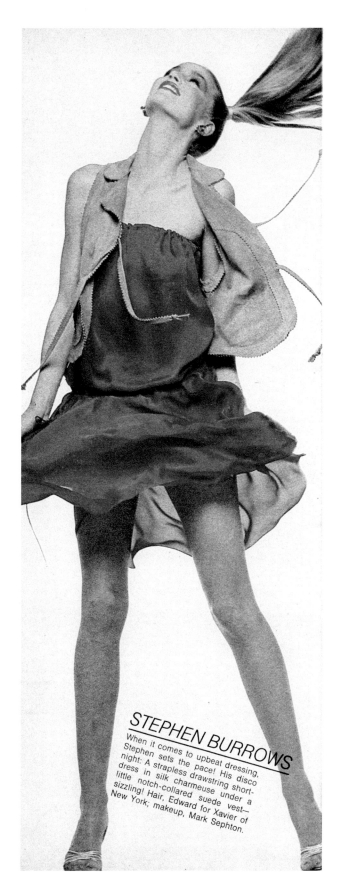

STEPHEN BURROWS

When it comes to upbeat dressing, Stephen sets the pace! His disco night: A strapless drawstring short-dress in silk charmeuse under a little notch-collared suede vest—sizzling! Hair, Edward for Xavier of New York; makeup, Mark Sephton.

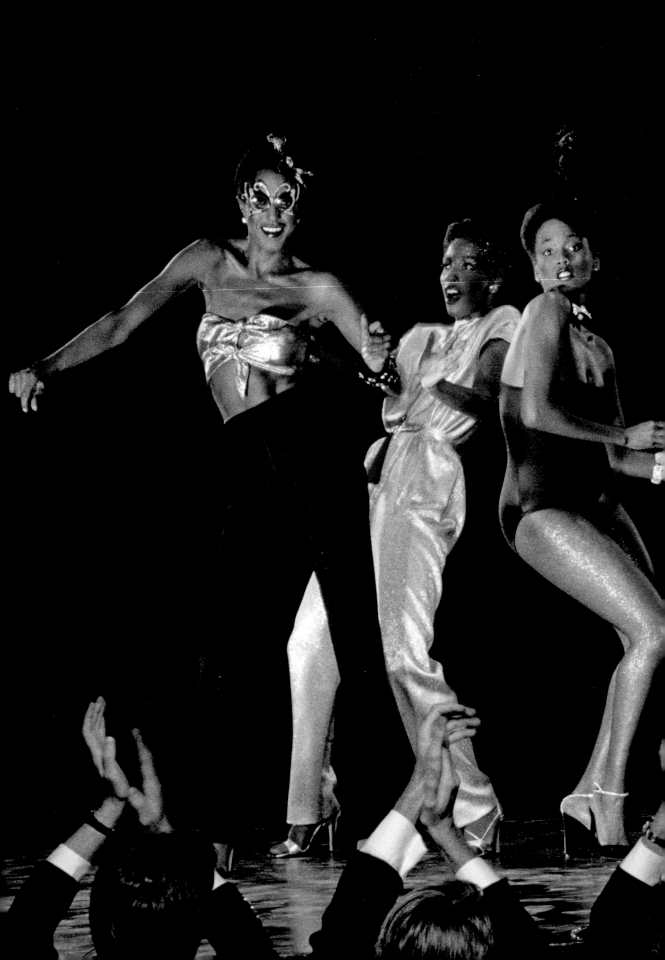

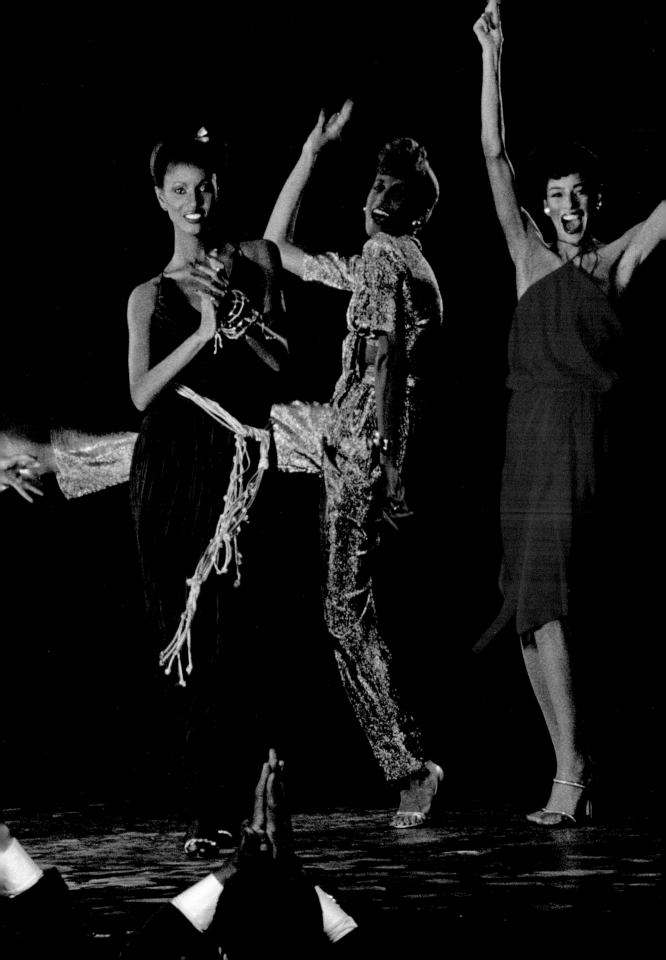

Previous Spread:
Model Billie Blair (far left) in gold bandeau and black matte jersey pants and Dana Dixon (far right) in red silk halter dress from an article on black models in *Vogue*, December 1978

STEPHEN BURROWS

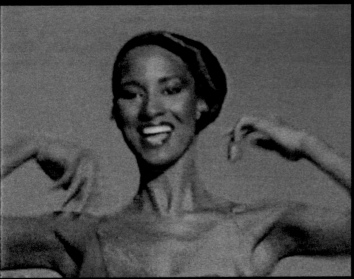

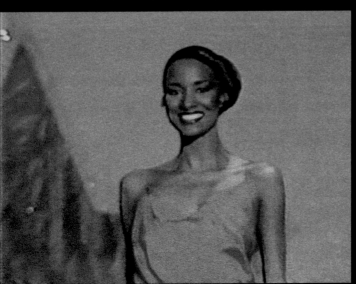

Opposite (above):
Deanna Lambert in wrap top
and skirt in matte jersey with
lettuce-edge finishing and
D.J. Don Fendley in Stephen
Burrows's "S" top, 1971

Opposite (below):
Berry Berenson dancing
with artist Richard
Bernstein, 1978

Left:
Images from "The Best Six"
fashion show, Tokyo, 1978

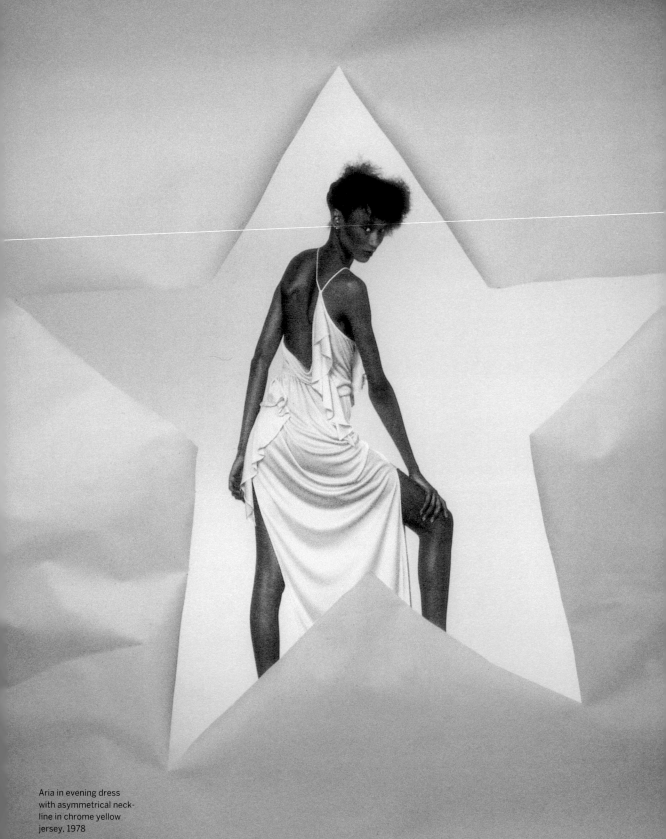

Aria in evening dress with asymmetrical neckline in chrome yellow jersey, 1978

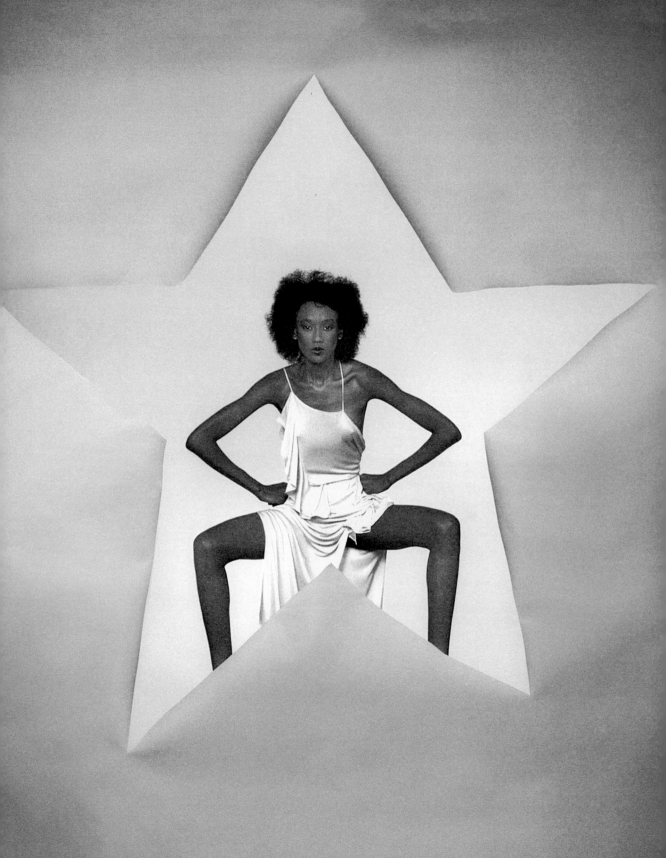

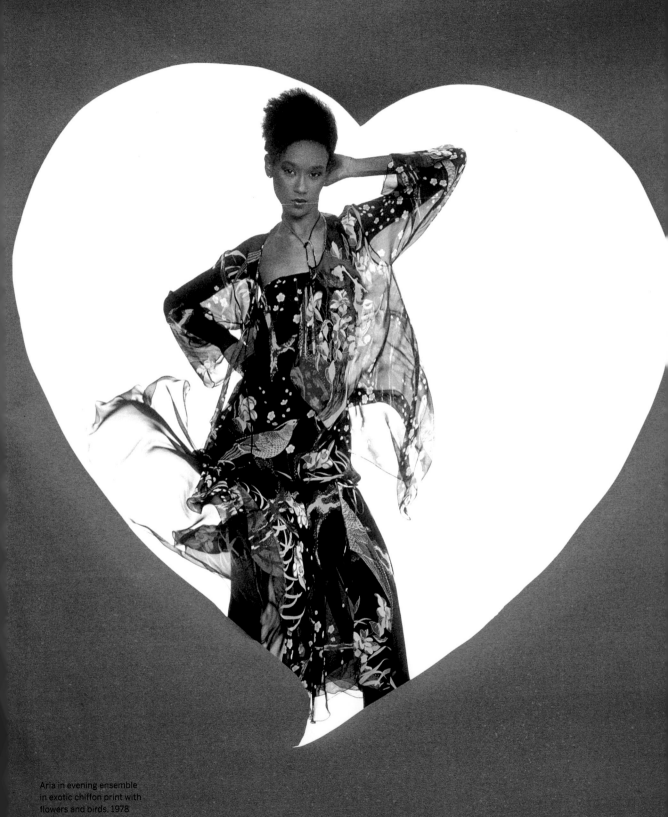

Aria in evening ensemble
in exotic chiffon print with
flowers and birds, 1978

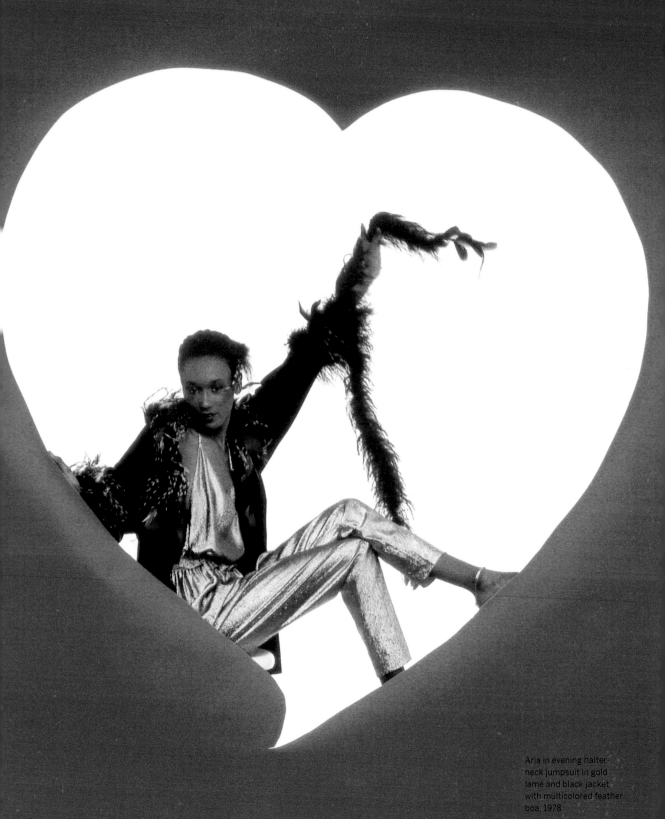

Aria in evening halter-neck jumpsuit in gold lamé and black jacket with multicolored feather boa, 1978

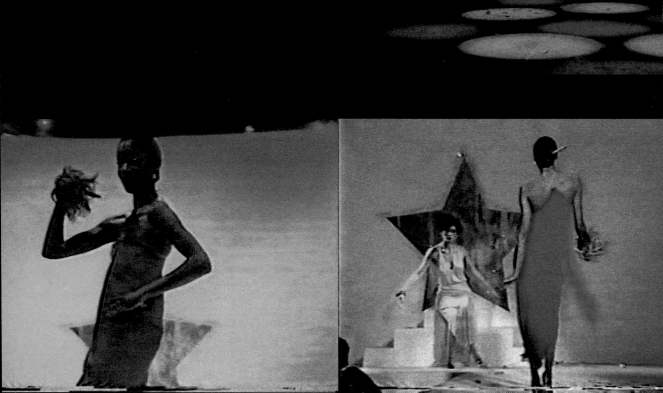

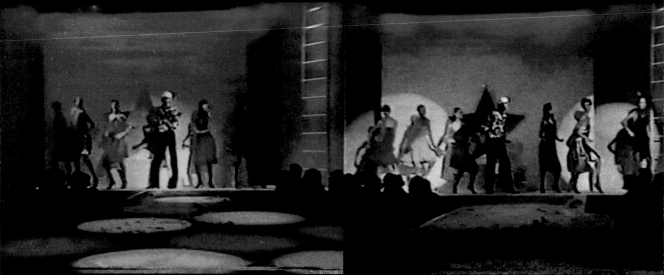

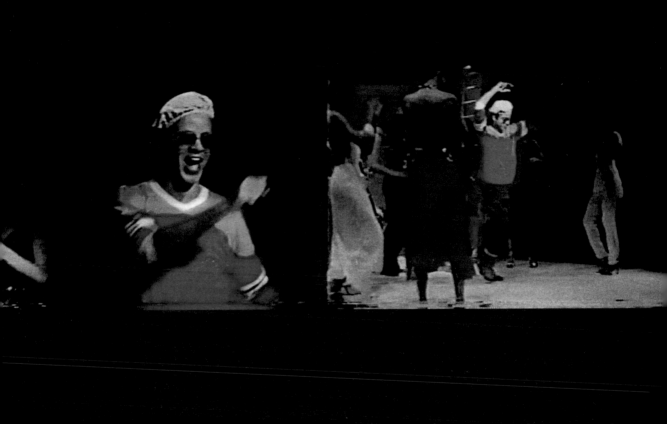

AUTHOR BIOGRAPHIES

Museum of the City of New York Curator of Costumes and Textiles
Phyllis Magidson has served as steward and spokesperson of the
Museum's renowned costume collection for over three decades
and has contributed to over sixty of the Museum's feature exhibitions.
Ms. Magidson has written for numerous publications, including
Paris/New York (2008), and her recent curatorial highlights include
Notorious & Notable: 20th Century Women of Style (2010) and
Valentina: American Couture and the Cult of Celebrity (2009).

An Italian-based fashion journalist, **Daniela Morera** has interviewed
performers, artists, and fashion designers around the world. She is
best recognized as a long-term contributor and European Editor for
Andy Warhol's *Interview Magazine* and New York correspondent
for Italian *Vogue*. In 2005, Ms. Morera curated an exhibition on Andy
Warhol at the Triennale Design Museum in Milan, Italy.

Widely known as an editor, critic, and writer on fashion, art, and music,
in 1971 **Glenn O'Brien** became Editor and Art Director of Andy Warhol's
Interview Magazine. He went on to hold positions at *Rolling Stone*, *Oui*,
and *High Times*. Recently he has served as *GQ*'s "Style Guy" and authored
the book *How to Be a Man: a Guide to Style and Behavior for the Modern
Gentleman* (2011).

Fashion historian and commentator **Laird Persson** is the author of five
books, including *Fashion Illustration Now* (2004), *Fashion Illustration
Next* (2004), and *The Cocktail Dress* (2009). An avid researcher and a
frequent contributor to leading fashion publications, she served as Senior
Fashion Editor of the highly popular online publication style.com for nearly
a decade. Ms. Persson received an M.A. from the Fashion Institute of
Technology, where she wrote her thesis on fashion journalism in *Vogue*.

Opposite:
Stephen Burrows in a
leopard-print tank
top of his own design,
captured for "The Best
Six" publication, 1978

Thank you to the many individuals and institutions who made this publication possible, including The Avedon Foundation, Marc Balet, Stella Benakis, Stephen Bluttal, Eva Bochem-Shur, Arleen Bowman, Paul Carlos, Sarina Cass, Margaret Rennolds Chace, Conde Nast and Edizioni Conde Nast, Hearst Communications, Inc., Francis Ing, Carrie Kawamura, Anton Perich, Klaus Puhlmann, Anna Marie Magagna, Charles Miers, Anthony Petrillose, Allison Power, Michelle Salmieri, Robert Sefcik, Allan Tannenbaum, and Charles Tracy.

PHOTOGRAPHY CREDITS

Unless otherwise noted, all photographs in this publication are by Charles Tracy and appear courtesy of the photographer.

2-3: © Oliviero Toscani/Vogue/Conde Nast | 4: Photograph by Berry Berenson, airbrushed by Richie Williamson | 6: Photograph by Francis Ing, art direction by Daniela Morera. Courtesy of the photographer | 8: © Helmut Newton/Vogue/Conde Nast | 10-1: © Women's Wear Daily/Conde Nast | 12-3: Courtesy Stephen Burrows | 14: © Ishimuro/Vogue/Conde Nast. Courtesy of the photographer | 19: © Charles Tracy/Vogue/Conde Nast | 20 (left): Photograph by Charles Tracy. Courtesy LOOK Magazine Photograph Collection, Library of Congress, Prints & Photographs Division | 20 (right): Courtesy Stephen Burrows | 21: Courtesy Stephen Burrows | 22-3: Photograph by Francis Ing, art direction by Daniela Morera. Courtesy of the photographer | 26 (left): Photograph by Frederick Kelly. Museum of the City of New York, Gift of Rena C. Kelly, 2001.59.9 | 26 (right): Photograph by Robert P. Sefcik. Courtesy of the photographer | 27: Photograph by Robert P. Sefcik. Courtesy of the photographer | 29 (top and bottom): Courtesy Arleen Bowman | 30: Photograph by Barbara Walz | 32-3 (top and bottom): Photograph by Francis Ing, art direction by Daniela Morera. Courtesy of the photographer | 34: Photograph by Francis Ing, art direction by Daniela Morera © Francis Ing/L'Uomo Vogue/Edizioni Conde Nast | 36: Photograph by Anton Perich. Courtesy of the photographer | 37: Photograph by Rose Hartman © Getty Images | 38: Courtesy Daniela Morera | 39: Sandro Botticelli, *Primavera*, ca. 1482. Courtesy Uffizi Gallery, Florence | 44: Photograph by Allan Tannenbaum. © Allan Tannenbaum--All Rights Reserved | 45: Photograph by Barbara Walz | 46: Courtesy Daniela Morera | 47: Photograph by Allan Tannenbaum. © Allan Tannenbaum--All Rights Reserved | 51: Courtesy Arleen Bowman | 67: © Jack Robinson/Vogue/Conde Nast | 75: © Sandy Norris/The New York Times | 89: Courtesy Stephen Burrows | 91: Courtesy Stephen Burrows | 94-5: Photograph by Bill King for Harper's Bazaar, Hearst Communications, Inc. | 96-7: Courtesy Stephen Burrows | 100: Photograph by Barbara Walz | 101: Courtesy Stephen Burrows | 102 (left and right): Courtesy Anna Marie Magnagna | 104-7: Courtesy Daniela Morera | 108-9: Courtesy Marc Balet | 113: Courtesy Stephen Burrows | 115: © The Richard Avedon Foundation | 116: Photograph by Joel Baldwin. Courtesy LOOK Magazine Photograph Collection, Library of Congress, Prints & Photographs Division | 124: Photograph by Rico Puhlmann. Courtesy Puhlmann Archives | 125: © Helmut Newton/Vogue/Conde Nast | 126 (left and right): Courtesy Anna Marie Magnagna | 127: Photograph by Barbara Walz | 132: Courtesy Renault White | 133: Photograph by Barbara Walz | 134: Courtesy Stephen Burrows | 135: Photograph by Barbara Walz | 136 (left and right): Courtesy Stephen Burrows | 137: Photograph by Barbara Walz | 138-9: Photograph by Chris von Wangenheim. Used with permission | 142-3: Photographs by Bill King for Harper's Bazaar, Hearst Communications, Inc. | 144 (bottom right): Photograph by René Volpi. Courtesy Daniela Morera | 145: Photograph by Francis Ing. Courtesy of the photographer | 146: Photograph by Anton Perich. Courtesy of the photographer | 147: Photograph by Francesco Scavullo. © The Scavullo Foundation and Scavulloeditions.com | 148: © ABC Photo Archives/Getty Images | 149: Photograph by Ron Gallela. © WireImage | 150-1: Photographs by Bill King for Harper's Bazaar, Hearst Communications, Inc. | 152-3: Courtesy Stephen Burrows | 157: © Bettmann/CORBIS | 158: Photograph by Rico Puhlmann. Courtesy Puhlmann Archives | 159: Photograph by Bill King for Harper's Bazaar, Hearst Communications, Inc. | 160-1: © Andrea Blanch/Vogue/Conde Nast. Used with photographer permission | 162 (top): © Charles Tracy/Vogue/Conde Nast | 162 (bottom): © Jack Robinson/Vogue/Conde Nast | 163: Courtesy Daniela Morera | 164-5: Photograph by Francis Ing, art direction by Daniela Morera. Courtesy of the photographer | 166-7: Photograph by Francis Ing, art direction by Daniela Morera. Courtesy of the photographer | 168-71: Courtesy Daniela Morera | 172: Photograph by Francis Ing. Courtesy of the photographer

This volume is published on the occasion of the exhibition *Stephen Burrows: When Fashion Danced* organized by and presented at the Museum of the City of New York, March 22–July 28, 2013.

First published in the United States of America in 2013 by

Skira Rizzoli Publications, Inc.
300 Park Avenue South
New York, NY 10010
www.rizzoliusa.com

in association with

Museum of the City of New York
1220 Fifth Avenue
New York, NY 10029
www.mcny.org

Ronay Menschel Director, Museum of the City of New York: Susan Henshaw Jones
Deputy Director and Chief Curator: Sarah M. Henry
Curator of Costumes and Textiles: Phyllis Magidson
Senior Curatorial Associate: Autumn Nyiri
Assistant Curator of Costumes and Textiles: Grace Hernandez

Editor and Art Director: Daniela Morera
Book Design and Typography: Pure+Applied, www.pureandapplied.com
Editorial Assistants: William DeGregorio and Laura McLaws Helms
Research Assistants: Christine E. Griffiths, Katherine A. Miller, Mimi Prober,
Anysa Cianni, Maria Echeverri Correa, Lauren Peters, and Ryane Disken-Cahill

Editorial support provided by Lilly Tuttle, Assistant Curator

Skira Rizzoli Publications, Inc.:
 Margaret Rennolds Chace, Associate Publisher
 Anthony Petrillose, Managing Editor
 Allison Power, Editor
 Kayleigh Jankowski, Design Coordinator

2013 2014 2015 2016 2017 / 10 9 8 7 6 5 4 3 2 1

ISBN: 978-0-8478-4118-9

Library of Congress Catalog Control Number: 2012956214

Printed in Italy

Frontispiece: Models (from left to right) Vibeka, Jerry Hall, Iman, Chris Royer,
Bethann Hardison, Kirsti Toscani, Pat Cleveland, and Alva Chinn with Stephen
Burrows in *Vogue*, 1977

This book and an exhibition it accompanies are
made possible by the generous support of Target.

Additional support for this publication is provided
by The Coby Foundation, Laura Lofaro Freeman, and
Furthermore: A program of the J.M. Kaplan Fund.

Furthermore:
a program of the J.M. Kaplan Fund